UP THE ROUGE!

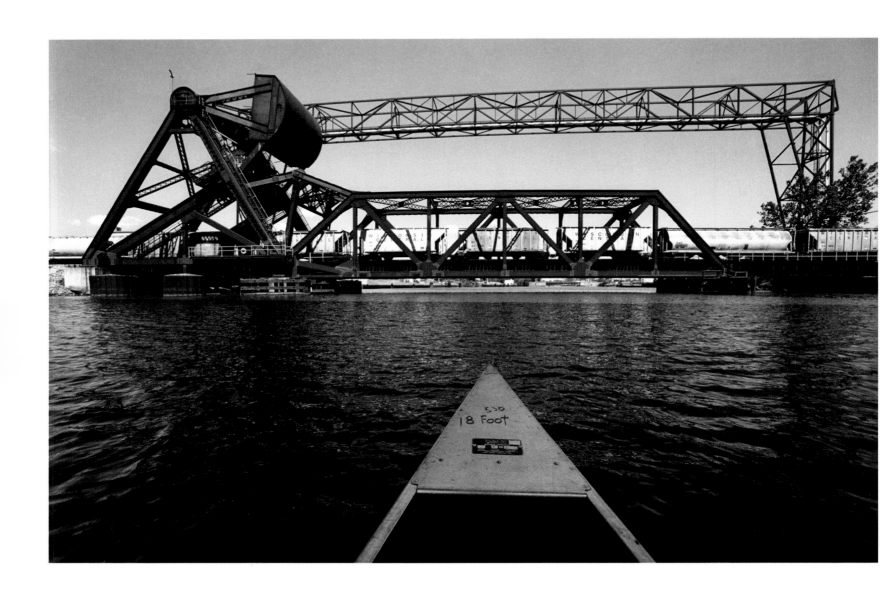

UP THE ROUGE!

PADDLING DETROIT'S HIDDEN RIVER

TEXT BY JOEL THURTELL ✕ PHOTOGRAPHS BY PATRICIA BECK

A PAINTED TURTLE BOOK DETROIT, MICHIGAN

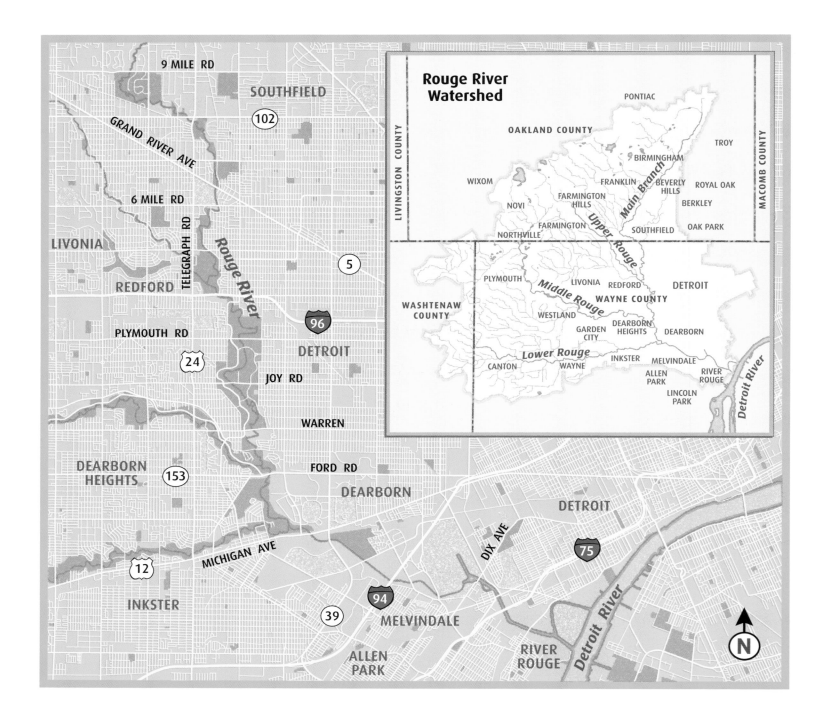

9 MILE RD

SOUTHFIELD

102

GRAND RIVER AVE

LIVONIA

6 MILE RD

TELEGRAPH RD

Rouge River

REDFORD

5

PLYMOUTH RD

24

96

DETROIT

JOY RD

WARREN

DEARBORN HEIGHTS

153

FORD RD

DEARBORN

DETROIT

12

MICHIGAN AVE

DIX AVE

75

INKSTER

39

94

MELVINDALE

ALLEN PARK

RIVER ROUGE

Detroit River

N

Rouge River Watershed

PONTIAC

OAKLAND COUNTY

TROY

BIRMINGHAM

LIVINGSTON COUNTY

MACOMB COUNTY

WIXOM

FRANKLIN

Main Branch

BEVERLY HILLS

ROYAL OAK

FARMINGTON HILLS

NOVI

Upper Rouge

BERKLEY

FARMINGTON

SOUTHFIELD

OAK PARK

NORTHVILLE

PLYMOUTH

LIVONIA

REDFORD

DETROIT

Middle Rouge

WASHTENAW COUNTY

WAYNE COUNTY

WESTLAND

GARDEN CITY

DEARBORN HEIGHTS

DEARBORN

Lower Rouge

INKSTER

MELVINDALE

CANTON

WAYNE

ALLEN PARK

RIVER ROUGE

Detroit River

LINCOLN PARK

CONTENTS

ACKNOWLEDGMENTS

We would like to thank the *Detroit Free Press* for permitting the use of Pat's photos in this book. Also, thanks to our editors at the *Detroit Free Press* for believing in our Rouge canoe project and helping to make it happen, both on the river and in the newspaper: Kathy O'Gorman, Kathy Kieliszewski, Laura Varon Brown, and Nancy Andrews.

Extra thanks to Kathy Kieliszewski for lending her keen eye and expert judgment during the photo selection for the book, and to Jessica Trevino for her artistry in preparing the photos for publication.

We are honored to have our book included under the Painted Turtle imprint and wish to thank all of those at Wayne State University Press for their belief in our book and for the effort and skill they brought to its production. Kathy Wildfong supported us from the beginning. Linnea Fredrickson's copyediting improved the book in many ways. Carrie Downes Teefey kept us moving towards production. We'd like to thank Maya Rhodes, who typeset the book; Chang Jae Lee, who designed it; and Matt Kania, who created the maps. Thanks to all whose efforts great and small made our dream of this book a reality.

Special thanks to Al Heavner of Heavner Canoe Livery, who committed to our idea from the beginning and thought of solutions to tricky logistic problems. Al and his assistant, Nancy Yipe, were our guardian angels for our odyssey up the Rouge.

I am most of all grateful to my wife, Karen Fonde, for her support and enthusiasm, which continued long after the canoe trip as I wrote and re-wrote the book.

PROLOGUE

CANOEING THE DIRTIEST RIVER IN MICHIGAN

An electric *WHIRRRRRR* and then a loud metallic *CLANK* came from behind one of a half dozen solid steel gates looming over us. It was a little before 7:30 the evening of June 9, 2005. We were nearing the end of the fourth day of a strange, self-imposed newspaper assignment—paddling a canoe up the Rouge River in Detroit with the idea of writing stories about and photographing the experience.

I was sitting in the stern of the fifteen-foot Michi-Craft. My colleague, photographer Pat Beck, was in the bow. We were drifting in front of these six big doors notorious for disgorging very nasty stuff from a sewage retention basin into the river whenever it rains. Pat was pulling out one of the *Detroit Free Press*'s last 35mm film cameras from a waterproof bag. Film cameras had been almost completely replaced by digital equipment at the *Free Press,* and I doubted that her editors ever imagined what would have happened if these gates had opened

just then. But their intuition was correct. If something bad happened to us on this *Free Press*–sanctioned expedition—and bad things almost happened to us several times—at least the paper wouldn't lose a $7,500 digital camera.

We'd heard thunder rumbling from somewhere to the north. We'd been warned: If it rains, get off the water. Fast. The Rouge is very, very "flashy." Its small channel can't handle anywhere near all the stormwater that rushes off streets, parking lots, houses, stores, and factories straight into the river. It can rise rapidly, spreading across large areas of nearby floodplain, washing out bird and fish nests, violently rearranging the myriad logjams that clog the stream, and potentially overwhelming and drowning those human beings foolish enough to be on it in a canoe when a "rain event" happens.

A state fisheries biologist once told me that the Rouge is "the dirtiest river in Michigan." Of all the places on this filthy river you would not want to be when it rains,

the worst would be right where we were maneuvering under these gigantic mechanical anuses, the huge combined sanitary and storm sewer outlet just south of Six Mile Road and east of Telegraph Road. When it rains hard and those gates open, they release hundreds of thousands of gallons of human feces, urine, tampons, sanitary napkins, toilet paper—more miscellaneous human waste than you can imagine, along with industrial castoffs like motor oil, gasoline, and solvents—straight into the river. The deluge would be aimed right where we were sitting in that little canoe loaded with cameras, lenses, hip waders, pruning shears, measuring sticks, and our precious drinking water bottles.

That would have been a good time to ask ourselves why we were trying to canoe up this river where—as the fisheries guy told me—"people won't recreate" because of all the crap. Downstream a little while ago, having battled our way over a huge logjam with somebody's junked sailboat on its crest, we floated under what looked like a bulging, buff-colored water balloon. It hung from a branch over our heads as we paddled toward its concrete and steel source. This was somebody's used condom, flushed down a toilet, swirling its little latex path through a sewer main to that basin near Six Mile Road where a rainstorm had overloaded the pipes and blasted this bloated rubber along with thousands of gallons of unthinkable crap and pee straight into the stream where we now sat in a flimsy metal canoe.

When that electric motor started, followed by the clanking, we had only one thought: if the gates open, we'll be swamped, inundated, blasted away by . . . the polite word is "waste," but that wasn't the word that came to mind. "Shee-it!" I yelled. We paddled like hell.

A RIVER HIDDEN IN A CITY

I never met a river I couldn't canoe, swim, or fish until I moved to the suburbs of Detroit. There, in 1984, I first encountered the Rouge, the longest river in southeastern Michigan. Its four branches and tributary creeks drain 466 square miles, including forty-eight towns in three counties—Oakland, Washtenaw, and Wayne. It runs 127 miles through urban and suburban Detroit. A million and a half people live in its watershed. Its name was given to the most famous automobile factory in the world, the Ford Motor Company River Rouge Plant. You'd think that people would flock to a river like that. Yet you can't swim in the Rouge River. You're not supposed to canoe it either. Fishing is restricted or completely banned.

Not far away is the Huron River, where I canoed years ago. On the Huron, there are four liveries that will rent you a canoe. On the Huron there is excellent fishing. There are city parks, metro parks, twenty-three public restrooms, and twenty-three public boat ramps. I have actually sailed on the Huron. Meanwhile, the Rouge remains unpopular, even with its famous name, thanks to many bad things done to it by many people. It is actually becoming a worse place for people and wildlife. (See the 1999 and 2005 reports titled *Rouge River Report Card*, published by the Rouge Remedial Action Plan

Advisory Council and available at http://www.epa.gov/grtlakes. Follow the links to "Areas of Concern," "Rouge River," and the reports.)

It is a hard river to know. It has no canoe liveries. The water is too laced with sewage for people to swim. Amazingly, in this densely populated urban area, it is even hard to see in many places. Often, it is like a wilderness, just narrow and winding. One public restroom is near one boat launch on just one branch of the river that might—with hard work and lots of risk—be canoed.

This is the Rouge River, and despite more than a billion dollars spent on cleanup and on burnishing its reputation, it is still polluted. By design, the Rouge is a spare pipe for Detroit's sewer system. Municipal sewers each year dump two billion gallons of human waste mixed with stormwater into the Rouge. That's down from six billion gallons in 1992, a 67 percent decline, so no doubt about it, there have been improvements, and more are in the works. But two billion gallons is a lot of disease-spreading sewage. Because the Rouge River is a part of the sewer system, city parks long ago were designed to keep people away from the water. You can eat a picnic lunch beside the Huron in Ann Arbor, but in Detroit's big parks, picnic tables are far away from the Rouge.

This situation was mostly unknown to me when I moved to the Detroit suburb of Plymouth Township in the early eighties. On my daily commutes to a *Free Press* bureau office, I drove along the Middle Rouge River. I was amazed to see woods. What a surprise for a guy

from western Michigan, who thought the city was all paved over. Hoping to learn more, I rode a horse with the Wayne County mounted police, and in the woods alongside the Middle Rouge I saw an egret, a wood duck, and a green heron—birds I'd never even seen in the boonies around Lowell, where I grew up.

From horseback, I saw more than bucolic scenery though. I saw the ugly side of the Rouge: combined sewer outfalls that disgorged their awful fluids into the river; picnic tables awash in the current; an incredible variety of cast-off urban detritus littering the streambed and its banks; comfort stations and picnic shelters burned or otherwise vandalized; bridges washed out or destroyed.

I wondered what it would be like to canoe the Rouge. I had learned to swim in the Flat River at Lowell. We built rafts that we poled around the river. When I got older, I canoed on the Flat. It seemed to us a clean, pure stream. When I talked to Detroit people about canoeing the Rouge, I was told I'd get sick if I tried it.

Pat Beck grew up in Beverly Hills, north of Detroit. The Rouge runs right through that village. Once, for a story, Pat and I rented a canoe and spent an afternoon paddling through Beverly Hills in a secluded, rustic-looking area called Hidden Rivers. We were amazed. Except for faint traffic sounds, we might have been in northern Michigan. We knew the water running under our canoe would flow on through Southfield, Detroit, Dearborn Heights, Dearborn, Detroit again, Melvindale, Allen Park, and River Rouge. We hatched a grand idea that day: we should canoe the entire Main Branch

of the Rouge. We decided without even asking, though, that it was unlikely our editors would ever let us do it.

But for two years, we never forgot the idea of canoeing more of the river. I told people about it, and one day a former colleague who is knowledgeable about the Rouge shot me an e-mail message. The gist of its contents was that 2005 was the twenty-year deadline for cleaning up the Rouge so that people could swim and fish in it again. Strides had been made, certainly, but obviously the job was far bigger than anyone had imagined.

Everyone knew the river was still polluted. People were less likely to know, however, that in many, many places it's plugged with old dams, junk cars, and dozens of logjams. A canoe trip on the Rouge, reported in a *Detroit Free Press* story with color photographs, might focus public attention on the neglect and outright abuse of the river. Maybe such publicity would motivate more people to see it as a thing worth cleaning and protecting.

Over the last roughly quarter century, various governments have spent $1.6 billion trying to rid the Rouge of pollution from municipal and private sewage. But the Rouge itself remains for many a distasteful reminder of the downside of industrial society. Sadly, scientific evidence shows that during the past few years, some of the progress has been reversed. What if, we wondered, people understood that this river—long regarded as a sewer—is a resource and in many places truly a thing of splendor? What if we could spark interest in the Rouge as a place to have fun, a place to go walking, biking, bird-watching—maybe even a place to go canoeing?

When we eventually floated our idea at the *Free Press*, editors expressed concern that we might provoke copycats. What if some reader was hurt or killed and the paper was sued? Our feeling was why not let others try it? Why not inspire people to see the Rouge up close, see for themselves what beauty lies within reach, see what a great place this is, well worth saving and improving. If we canoed the Main Branch of the Rouge, we might unlock the river's secrets. If we shared our amazing discoveries with others, maybe there would be greater interest in learning more about—and caring for—this important piece of our landscape. Despite all the harm we've done to the river, it is still the closest thing to an urban wildlife refuge that exists, largely hidden, in our backyard.

PLANNING FOR A CANOE TRIP

The April 21, 1983, *Free Press* headlined a story about two staffers—artist Roger Hicks and reporter Gary Graff—who had tried to canoe down the Franklin Branch of the Rouge and wound up in the drink. Jean Salkowski, a riverfront homeowner, had happened to look up and see them headed for "a real bad turn." She went out to see what happened. Later, Salkowski told another *Free Press* reporter, "I know the current is real strong now. They were jammed up against the riverbank next to a tree. They were holding onto the canoe for dear life, in water up to their noses, trying to catch their gear."

They were lucky someone saw them. There are few places anywhere on the Rouge where a canoeist can be seen, let alone get help. Salkowski gave them blankets, hot tea, and soup, and lent them some clothes.

"We were lucky. We were really in trouble," Graff said. Afterward, he caught a cold and got a shot of penicillin.

"Any fool going down the river at this time of year needs somebody's help," Salkowski said.

Maybe Pat and I were also fools for wanting to canoe the Rouge. But at least we could be savvy fools. Not likely would there be a Jean Salkowski to help us if we got in trouble. The Rouge is isolated, surrounded mostly with woods, studded with logjams, and contained within banks that are high, sheer, and slick. Help is not likely because, mostly, people aren't looking at the Rouge.

If we wanted to stay out of trouble, planning was going to be critical. It boiled down to real basics, such as not taking the trip when the water is high and getting off if it should rain. In the nineteenth century, settlers canoed up the Rouge because there were no roads. And because there were no roads—and no subdivisions, parking lots, and massive manufacturing plants with massive roofs—there was not the problem of massive runoff sluicing straight into the river. Back then, it soaked into the ground and was filtered and slowed down. Now the river's level can fluctuate by ten feet in twenty-four hours—a scary thought for a canoeist.

We couldn't turn back the clock, but we could plan our trip for a time when, historically, water levels are not terribly high. The U.S. Geological Survey (USGS) has been reporting monthly streamflow statistics for the Rouge since October 1930. In April 1983, when Graff and Hicks made their attempt, the USGS reported that 317 cubic feet per second (cfs) of water was passing down the Rouge. Had the pair waited until June, the flow would have been just 127 cfs. They would have had a slower, gentler ride.

Planning meant making and revising lists of the things we thought we'd need. It meant debating the merits of plastic versus aluminum canoes. (We decided aluminum would give us better protection against metallic junk that might puncture our canoe's hull.) It meant many trips to the Rouge to look for places where we could put a canoe in or take one out. At the time, I was covering the so-called Downriver area for the *Free Press*. That's a vast, anomalous area of suburbs south of Detroit starting at the Lower Rouge and extending to Monroe County. On my way to anywhere in Downriver to interview people or pick up police reports, I would drive along Telegraph Road, a broad street that runs alongside the Rouge for roughly a dozen miles in Oakland County and Detroit. Using handy 8½-by-11-inch USGS maps, I would stop at roads that crossed the Rouge, looking for the bridges that were often the easiest entry and exit points. I would scout behind restaurants, shopping malls, a cemetery, and golf courses that abutted or surrounded the Rouge.

We had to decide where to launch the canoe on the first day. We seemed to have two choices: in the suburb River Rouge, there was Belanger Park, which faces

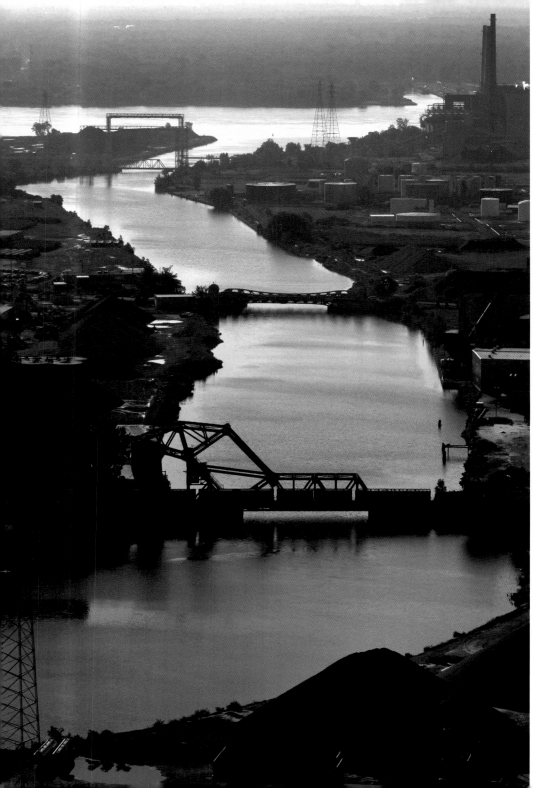

the Detroit River a half mile or so south of the Rouge's mouth, where it splits around Zug Island. Or there was Delray Park, roughly a half mile north and upstream of Zug Island. If we put in at Belanger Park, we would most likely turn west into the Short Cut Canal which leads the Rouge around the south side of Zug Island, site of three big blast furnaces owned by United States Steel Corporation. If we embarked from Delray Park, we would likely turn right at the north end of Zug Island, paddling up the natural course of the Rouge. Canoeing north from Belanger would mean paddling against the seven-mile-per-hour Detroit River current, but leaving from Delray Park would give us a seven-mile-per-hour push. Pat and I checked both Belanger and Delray parks. The decision seemed like a no-brainer. Why buck the Detroit River current? We'd launch from Delray Park.

RESTROOMS OF THE ROUGE

As we talked over other plans for the trip, Pat hit me with a question about a problem that I already had a plan for solving. Or so I thought.

"What are we going to do about bathrooms?" she asked.

"We'll take a roll of toilet paper and a shovel," I replied.

"No, we won't," Pat said. "We will find bathrooms."

And so we would. Well, sort of.

Whenever I talked to people who know the Rouge,

PROLOGUE

they told me that on the Rouge's Main Branch, the only public restrooms are in the Melvindale Ice Arena, which happens to be near the only public access on the entire Rouge River. It's about four miles from the mouth of the Rouge, though, and we were planning a trip that we hoped would take us thirty or more miles up the Rouge.

So began a quest for facilities that was more interesting for what it didn't yield and for many unrelated things I discovered along the way. I got out my topo maps and began hunting for places that might have unmapped johns.

Delray Park, our starting point, had Porta-Johns, I knew. What about the U.S. Steel iron-making plant on Zug Island? Too soon—it's only half a mile from Delray Park, and we wouldn't need a bathroom yet. Also, its sea walls are too high to get over from a canoe.

Next I thought of the Fort Street drawbridge. I'd been in the control tower for a story. A bridge tender is there all the time, so it would have to have a john. For this trip, I had made a laminated pocket-size card with key phone numbers on it, and sure enough the Fort Street bridge tower phone number was there. I would remember to bring my card along on the trip.

After that, I called a public relations person at Ford Motor Company. No, I was told, you won't be able to use a restroom at the Ford Rouge plant.

Darn.

I knew the Melvindale Ice Arena has potties. What I found out just before we launched is that the ice arena is often closed during daylight hours, when canoeists are out. It was not going to be so great an option after all.

The Rouge runs past Greenfield Village, Henry Ford's theme park on nineteenth- and early-twentieth-century American living. It has plenty of restrooms. But a public relations person there told me we'd wreck our canoe if we tried to come aground on the concrete pavement that underlies that section of river. Frankly, that sounded (and turned out to be) absurd, but I didn't argue.

Fair Lane Manor, Henry Ford's mansion in Dearborn, has primo facilities. While doing a story about Ford's hydroelectric plant at the manor, Pat and I had checked on them. First rate!

Parkland Park in Dearborn Heights has public johns. Before the trip, I tested the men's room. Acceptable.

I drove through Detroit's River Rouge and Eliza Howell parks. No restrooms! Unbelievable. Really, I was incredulous—two huge city parks with no toilets at all? I checked the Wayne County parks map of the Rouge and confirmed that there are no facilities in those sprawling parks.

After Dearborn Heights, we'd be holding our pee for a long, long time, it seemed. No public facilities accessible from the Rouge exist anywhere in Detroit. The first one would be in Southfield. Adjoining Detroit to the north, Southfield is a city that starts at Eight Mile Road and contains nine miles of the winding Main Branch of the Rouge River. It's more than twenty miles from the mouth of the Rouge. In fact, one of the best loos is at Beech Woods Golf Course on Beech Road south

In the late summer of 2005, we retraced our canoe route, but this time we were a thousand feet above the Rouge River, riding in a helicopter. The river pictured here, looking southeast toward the Detroit River, has drawn manufacturing since the earliest times of white settlement. Iron-making, ship-building, automobile manufacturing, and other industrial activities such as the processing of salt, cement, and gypsum have taken place on the Rouge.

of Nine Mile Road, a mile as the crow flies north of Detroit, but much longer in twisting river miles. The unisex restroom with sink and flush toilet at hole three is just twenty yards from the Rouge. It's almost as if somebody had us and our canoe trip in mind.

At this point in the search, I stopped and thought *wait a minute*. I'd been thinking only of public restrooms. There had to be other possibilities in case of emergency. On Telegraph, not far from Eliza Howell Park, there's a Wendy's fast-food restaurant. On second thought, I remembered the bulletproof glass that separates workers from customers. We had better stick with the river through this neighborhood.

North of Six Mile, Grand Lawn Cemetery has very nice bathrooms. I tested one when I visited the cemetery office to ask if it was okay to launch and pull out a canoe on their grounds. Steve Doles, the manager, was very helpful, and the Grand Lawn lav is first rate.

After collecting the results of this research, bottom line, so to speak, was that I myself would indeed plan to pack a trowel and a roll of toilet paper.

LOGJAMS AND DANGEROUS PADDLING

"Defeated by the tangles south of Outer Drive," wrote Bob Pisor, a former *Detroit News* reporter, in his October 1979 *Monthly Detroit* article recounting how he gave up his attempt the previous summer to canoe up the Rouge. His article was called "My Search for the Source of the Rouge." He began his journey in a canoe, alone. The trip was okay on the Lower Rouge, where the river is either kept clear and deep for freighters or paved to retard flooding. But when he ventured north of Michigan Avenue, he discovered the wilderness Rouge, with logjams unbelievable in their length and complexity. He would portage, removing all his gear from the canoe, hauling it and the canoe around the jams, and then launch and reload the canoe and proceed on to the next mess. About fifteen miles from the river's mouth, he left the river, found a phone, and called his wife. She took the canoe home, and he continued on foot.

Pisor's old article was helpful but in a flip-flopped way. It's a primer on what not to do. Don't go it alone, for one thing. He also didn't scout the river beforehand to find emergency pull-out places or just to familiarize himself with the personality of the river. Anyone who plans to canoe the Rouge should get to know the river from its banks first. Go to the bridges and learn the put-in and take-out places.

Canoeing the Rouge is risky from more than a health standpoint. Those logjams—dozens and dozens of them—along with several ruined dams are dangerous for canoeists. I once took a Power Squadron basic boating course. (The Power Squadron is a national organization devoted to training people to be safe boaters.) The textbook *Boat Smart* points out that 75 percent of drowning victims would have lived if they'd worn a life jacket. Fine—we planned to wear life vests. But the book also says that 20 percent of those who drowned actually were wearing life preservers.

"What happened?" the book asks. Here is the explanation:

A significant number of victims were paddlers such as canoeists and kayakers. Paddlers have a few things working against them if they should happen to have a mishap. One, they tend to boat in remote areas far from help. Two, they often paddle alone or with just one other person. Three, their vessels are relatively unstable and easy to capsize. Paddlers are particularly at risk from entrapment. Entrapment occurs in flowing water when the boater becomes snagged on rocks or debris at a hazardous point called a strainer. The paddler is trapped under water because of the severe hydraulics of the water flow and pressure. If the boater cannot escape quickly, it makes no difference what kind of life jacket is worn—the result will be drowning.

The dynamics of a logjam would impress us the very first time we approached one of these snarls of logs, trees, construction debris, and myriad forms of trash in our remote urban setting. I recall measuring the water depth on the downstream edge and realizing that our six-foot gauges wouldn't touch bottom. The Rouge north of Michigan Avenue normally is not very deep, but at logjams, the water is funneled into a narrow spot, and its natural tendency is to plow its way downward as it seeks an exit. The current may be quite gentle a few yards upstream, but at the jam, it races be-

neath the debris pile.

"The result will be drowning."

Add to that grim formula the river's habit of rising rapidly when it rains. Picture a steep, slippery-walled trough with a flood of water aimed at you as you're pulling your canoe under, say, a tree fall or over a logjam. The Rouge is definitely a dangerous place.

Mark Phillips knows about the danger. He's a Birmingham science teacher with a passion for canoeing. He canoed down the Rouge from Civic Center Drive in Southfield to Belanger Park in River Rouge during the summer of 2004. He didn't make the trip all at once but separated his outings by days and weeks. Sometimes he was alone, sometimes he traveled with a friend. He helped us plan our trip. He gave us the handy 8½-by-11-inch color maps that I had laminated.

Mark warned me about the huge logjams he'd counted: fifty-two between Civic Center Drive and Fair Lane. And dams too—the working dam at Fair Lane and ruins of dams in other spots that deflected the current in dangerous ways.

Fifty-two logjams sounded like work. It gave me pause for reflection. When I started planning this expedition, I was fifty-nine years old. By June of 2005, I would be sixty. I considered myself a high-energy kind of guy. I sail and ski, and I run. But for several years, I'd been bothered by a sore shoulder. I realized that if my shoulder flared up during this trip, it could cancel the whole effort. At the insistence of my wife, Karen Fonde, who's a physician, I saw a sports medicine doctor. He told me I had tendonitis and gave me an elastic

strap and some simple exercises to do. I went home and soon devised a more elaborate set of exercises using ten-pound dumbbells. I did sit-ups every day, and I ran three miles. By June, there was no sign of tendonitis in my shoulder. My weight for a six-footer was in the 170s (it would dip to 169 pounds by the end of the trip), and I was feeling very fit.

Still, fifty-two logjams was a lot. Every time I visited the secluded portions of the Rouge on foot, it seemed more and more like a deep, muck-lined ditch shrouded by bushes and trees. A hard place to get out of if you ran into trouble. I worried about that and pondered what we'd do if we suddenly needed to exit the river but were stopped by a sheer bank. I thought about taking mountain-climbing gear, but after talking to Pat we decided any special equipment would just add to our load. We would be doing a lot of portaging, for sure, but how we'd elevate ourselves over those embankments was not clear. I planned to bring along plenty of rope, but we would have to play it by ear. Needless to say, I was not satisfied, and it worried me.

WHETHER TO TRAVEL UP
OR DOWN THE ROUGE

"We are explorers," Pat told me. We would not be tourists. We were trying to know the Rouge in a way that few are willing to attempt. We should therefore act like explorers. We should not coast downstream. Instead, we should start at Zug Island, at the river's mouth, and paddle upstream. We should follow the path that early explorers and pioneers took. Like Israel Bell. He was nineteen years old in 1818 when he and his wife, Laura, who was fourteen years old, traveled twenty miles up the Rouge (we don't know what kind of boat they used) to settle land on a tributary now known as Bell Creek. Today their homestead is property on Pomona Road just a half-mile north of Five Mile Road in Redford Township. They would have started at the original mouth of the Rouge on the Detroit River (without the manmade Short Cut Canal) at the north end of what is now Zug Island but then was a huge marsh.

Still, up the Rouge? Whenever I've gone canoeing, I've taken a downstream trip. That's how I did the Huron River and the White River. But then I also remembered that a long time ago I used to paddle an old wooden canoe on the Flat River. My friend and I paddled that canoe wherever we pleased—up, down, and crossways.

In thinking about the Rouge, I pondered the steep parts along the Middle Rouge that I knew best from that horseback ride years earlier. The Rouge has four branches—Lower, Middle, Upper, and Main. As its name suggests, the Main Branch is the widest, deepest, and most powerful. Between Northville and Livonia on the Middle Rouge there's a roughly three-hundred-foot drop in elevation. In the nineteenth century, millers and sawyers found fast-flowing water in several places along this stretch to run machinery. Henry Ford took over

some of those places for his Village Industry automobile parts factories and even lit his Dearborn mansion with generators run by water. But mostly, the Rouge, especially the Main Branch, doesn't drop very steeply. Between Michigan Avenue and Zug Island, a nine-mile stretch, the river descends one foot in elevation. The Main Branch of the Rouge is not a fast-moving stream. The river's typically gentle flow arrives slowly at the relatively more fast-moving Detroit River and instead of rapidly joining the larger stream, it slows, and sometimes even backs up. So, it would not be hard to paddle a canoe up the Rouge.

Okay then. Yes, Pat—up the Rouge!

When I told Mark Phillips about our upstream plan, he warned me that it would be harder to go against the current. We would not only be paddling against it, but it could not aid us in breaking through some of the minor logjams. The upstream plan worried Al Heavner too. His family owns Heavner Canoe Livery in Milford, and he was going to supply our canoe. Al urged us to change our minds. The problem with going upstream, he said, is that many tributaries join the Main Branch. Going downstream, it's simple to stay with the Main Branch because all streams flow into the big river. But heading upstream, we would be confronted with forks, and it might not always be easy to distinguish the Main Branch from, say, the Lower or Middle or Upper branches, let alone Pebble Creek or the Evans Ditch.

Don't worry, I told him. We'll have a map and a compass.

Brave words. Believe me, I gave serious thought to these objections. Al knows far more about canoeing on rivers than I do. Still, I didn't believe we'd get confused with the tributaries because from what I'd seen of the Lower and Middle Branches, they were much narrower and shallower than the Main. The others must be smaller still.

Something else was happening too. As I switched from thinking downstream to thinking upstream, my approach to the trip changed. I could no longer easily rely on Mark Phillips's detailed log because his observations were looking the opposite way we'd be going. There was no easy way to reverse his narrative, so I referred to it less and relied more on my own scouting of the river, always with a mind to what it would be like going against instead of with the current. Because of the upstream decision, we began subtly to put our own stamp, our own logic, on planning for the trip.

My editors, Kathy O'Gorman and Laura Varon Brown, and Pat's editors, Kathy Kieliszewski and Nancy Andrews, thought our idea was great. True, there had been some concern about liability, both in terms of the paper's concern about putting two staffers in harm's way and possibly inciting the public to try doing what we planned, which was dangerous. But those concerns soon disappeared. At the time, the *Free Press* was still owned by Knight-Ridder, a chain that has since disappeared, swallowed up in a corporate sale. But in winter 2005, led by *Free Press* publisher Carole Leigh Hutton, staffers were trying to "rethink" the role of the news-

paper, hoping to counter national trends of declining newspaper advertising and readership. According to Kathy O'Gorman, our canoe project was what "re-thinking" was all about.

Here are excerpts from my story proposal:

It's 2005, the year that once was targeted by environmental agencies as the time by which people would be able to swim safely in the Rouge and eat fish caught there without fear of consuming deadly contaminants.

Whoops.

Too optimistic.

Okay, the Rouge is somewhat cleaner. But a map of the watershed still shows many places where it's unsafe to touch the water.

The reek of raw sewage still hangs over extensive parts of the river.

The Rouge is still used as a dump by people needing to dispose of unwanted shopping carts, picnic tables and literally dozens of cars.

What must be done to achieve the goals that didn't happen by 2005?

One thing that could help, I wrote, would be a canoe expedition by the newspaper that would open the river's secrets, good and bad, to the public:

Canoe trip. Few have done it, because it's hard work. Especially in Detroit, where the river is criss-crossed with tree-falls, log jams, not to mention all those junk cars and other urban detritus. Wild dogs roam its banks. Goal of trip: Show that this hostile river can be canoed; that despite the terrible way it's been treated, wildlife—deer, herons, egrets, wood ducks, foxes, hawks—abounds. We encourage people to clean it up; encourage people to make it be what those 1980s environmentalists hoped it could be by 2005.

It was an unconventional story, Kathy O'Gorman told me, so it should be reported and written in an unconventional way. She urged me to buy a digital audio recorder so I could record what we did, what we saw and heard, and what happened to us as we canoed up the Rouge. We asked for six days. They okayed five.

We figured from our research that the spring floods should be over by June, so we set Monday, June 6, 2005, as our start day. Al Heavner offered us a deal: for $125 a day, he would provide not one but three canoes—a choice between eighteen-, seventeen-, and fifteen-footers. He would deliver the boats to us at the beginning of the day and pick us up in the evening, wherever we might be. That "wherever we might be" was a big question, given that the weather, the river's condition, and our own physical stamina were unknowable. But we'd have cell phones.

That we actually had approval from our editors and were actually going to do this thrilled us. But now a particular aspect of this project began to dawn on me,

something that had lurked in the background when it was still just a proposal. This was not going to be desk journalism. With most assignments, if there is a corner of the story you can't look into for lack of time or resources, or because somebody holds back information, you can still write the article. There's an old saying in journalism: "when in doubt, write around it." You may miss something, but nobody gets killed. Canoeing up the Rouge, this five-day project we were now organizing, was altogether different. We already knew about two former *Free Press* colleagues who had taken a dip in Franklin Creek, a tributary of the Rouge. A reporter can't write around that. They were lucky and got help, but this trip would take us through territory with few human river watchers as well as through neighborhoods where muggings and murders were not uncommon.

One of our biggest enemies, Mark Phillips warned us, would be getting depressed. The trip would be exhausting, both physically and mentally. "Discouragement," he wrote in one place in his log. "There are many obstacles and obstructions." After my editor Kathy O'Gorman read those words, she sent me an e-mail: "Are you guys nuts?"

No, we weren't nuts. Nervous, yes. Apprehensive, for sure. But we were doing things differently than our predecessors had. We would not be alone, for one thing. I wouldn't want to face the wilderness that is the Rouge by myself. It would be discouraging. But we were two fired-up people excited about meeting the challenge of the river, and we anticipated seeing and hearing amazing things. Being able to share the experience with a colleague would, we hoped, prevent the kind of depression and feelings of defeat that had plagued others.

WHAT MIGHT HAPPEN IF WE FALL IN

"If you go canoeing on the Rouge for five days, you're gonna get sick." A week before we launched our canoe, a friend with no special knowledge of the Rouge—just someone with a metropolitan Detroiter's standard low opinion of the river—gave me this warning. Believe me, I'd been thinking about the possibility of getting sick all during the time we planned this trip. What would happen to us if we fell in?

I posed this question to Susan Thompson, who works for the Wayne County Department of Public Health testing water in the Rouge. "There've been times when I've taken a dunk in the river," Thompson told us. "If you did dunk, basically, shower and soap."

I also checked with the Friends of the Rouge. It is a nonprofit organization that promotes the study and stewardship of the Rouge with the aim of encouraging public involvement in improving the river's ecosystem. One thing it does is organize a spring cleanup each year. The group warns participants not to expose cuts or sores to Rouge River water.

What did the Friends group know, and would Thompson's advice to shower and soap if we fell in

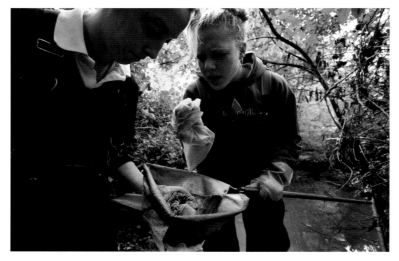

A tiny snail is caught in a net handled by Sam Santeiu, right, and Jessica Padmos, left, both Ladywood High School students in October 2005, as they searched for and recorded aquatic life in the Rouge River. Each fall, students throughout the Rouge watershed conduct water tests and search for aquatic life during field trips arranged by the nonprofit organization Friends of the Rouge.

On a tributary of the Rouge River in the suburb of Livonia, a Ladywood High School student, Erica Straub, tests a water sample for dissolved oxygen in October 2005. Dissolved oxygen is one of the Rouge River's success stories. Levels of dissolved oxygen meet state minimum standards.

be quick enough to head off infection if we also got scraped and cut while scrambling around the logjams? What if we went under and got water in our eyes, nose, ears, or mouth? These were not abstract questions for us.

So, I called the Department of Public Health again and this time talked to Rajendra Sinha, the supervisor of Engineering in the Environmental Health Division. I told him that I and a photographer colleague were going to canoe up the Main Branch of the Rouge in June and we were wondering how dangerous it would be for our health. How good—or bad—is the water in the Rouge, I asked him. What would happen if we fell in?

Sinha told me that while *E. coli* bacteria readings on the Middle Rouge had been better in 2004 than they had been in previous years, one year's data didn't mean a lot. Violations of permissible *E. coli* limits happened every time there was a significant rain. It was not safe to go for a swim, surprise or otherwise, in the Rouge River.

To discover what kinds of diseases we could get from sewage-polluted water, I surfed the World Wide Web and found the Centers for Disease Control and Prevention and the U.S. Environmental Protection Agency. I learned that human sewage carries bacteria and viruses that cause some pretty nasty human diseases. Viruses cause everything from common colds to fever, gastroenteritis, diarrhea, respiratory infections, and hepatitis. Bacteria cause gastroenteritis, salmonellosis, and cholera. Sewage in water has caused outbreaks of cholera, typhoid, and dysentery.

Cholera? In the twenty-first century in the United States of America? Thinking about cholera made me remember Jim Murray, the former head of Wayne County's Department of Environment who, as chairman of the Michigan Water Resources Commission in 1985 had set the 2005 goal of making the Rouge River "swimmable and fishable," and his telling me that in the days when Detroit simply ran all its sewage into the Rouge and Detroit rivers, there were actual cholera epidemics. I discovered in John Hartig's book *Honoring Our Detroit River, Caring for Our Home* that the first epidemic happened in 1832, and cases were still being reported in 1918. Detroit opened a wastewater treatment plant in 1940, but pollution of the Rouge and Detroit rivers continued to increase throughout most of the twentieth century, declining only in the 1990s.

I went back to Sinha. "Cholera? I don't know," he said. But he added, "It's a risk associated with raw sewage. I don't have any idea how many confirmed cases there are. There is a great potential [for] those kind[s] of diseases if people are drinking or coming in contact with that type of water."

Meanwhile, according to the U.S. EPA, the Narragansett Bay Commission, and the University of Rhode Island Office of Marine Programs (see http://omp.gso.uri.edu/doee/policy/org1.htm),

pathogenic microorganisms can infect humans through primary contact such as swimming or water skiing, secondary contact such as boating or fishing, and ingestion of contaminated shellfish.

Proper treatment of wastewater, combined with treatment of drinking water and immunizations, has nearly eliminated diseases like cholera, typhoid fever and polio within the United States. These diseases are still prevalent in other parts of the world. Presently in the U.S., about two thousand illnesses and ten to twelve outbreaks per year are attributed to waterborne microorganisms. This is ten percent of the number of incidents that occurred prior to the development of public sewers and water treatment systems.

Two thousand illnesses? That figure didn't sound good to me. I was disappointed that we still have people getting sick because there's sewage in our lakes and streams. I wanted us to have been better than that by now.

It was really sinking in that this canoe trip was not going to be a vacation.

We were going to be exploring the Rouge River on behalf of *Free Press* readers. We would be paid for our time. We would be working. A thought occurred to me: if we're at work, and there's sewage in our workplace, does that make us sewer workers? A little googling found for me the British Web site Health and Safety Executive and the article "Working with sewage: The health hazards—A guide for employers." It's a good thing our editors at the *Free Press* didn't read this thing. The authors

listed government sewer inspectors and sewer maintenance workers, construction workers, water company employees, sludge tanker drivers/operators, plumbers, and "employees who clean and maintain the underside of railway carriages and empty aircraft sewage compartments" as the people who routinely encounter human waste. I guess they didn't imagine journalists as sewer workers.

Here are some of the illnesses the article lists that can afflict people exposed to sewage as part of their job:

- Gastroenteritis, characterized by cramping stomach pains, diarrhea, and vomiting
- Weil's disease, a flu-like illness with persistent and severe headache, transmitted by rat urine. Damage to liver, kidneys, and blood may occur, and the condition can be fatal.
- Hepatitis, characterized by inflammation of the liver and jaundice
- Occupational asthma, resulting in attacks of breathlessness, chest tightness, and wheezing, caused by inhalation of living and dead organisms
- Infection of skin or eyes
- Rarely, allergic alveolitis (inflammation of the lung) with fever, breathlessness, dry cough, and aching muscles and joints

I also made a call to Colleen Hughes, a PhD chemical engineer who analyzes Rouge River water sampling results. She was studying test results from the summer of 2004 from the Main Branch of the Rouge at Beech Road and Eight Mile, the Wayne-Oakland county line. Of the fifteen samples taken during dry weather between May 19 and September 28, 2004, all readings were between 300 and 1,000 colonies of *E. coli* per 100 milliliters of water, she said, which meant the water was safe for canoeing but not for swimming.

Additionally, of thirty samples taken during wet weather between May 21 and November 1, 2004, 21 percent showed that the river was okay for canoeing, but 79 percent of them showed it not safe for any body contact at all. Twenty-one percent of the samples tested between 130 and 1,000 colonies of *E. coli*, while 79 percent contained more than 1,000 colonies.

Throughout the watershed, according to Hughes's data, it was safe to fall into the Rouge at best 5 percent of the time. Ninety-five percent of the time, beware!

How did these depressing data translate for us canoeists? Whatever you call it—work, play, recreation, or an oddball vacation—you'd have to be nuts to venture out on the Rouge. Or be committed to showing people what this maligned and abused stream is really like.

TAKING IN STRIDE WHATEVER COMES OUR WAY

One sunny day the week before our trip, I stood on the Rotunda Drive bridge looking over the 180-foot-wide

concrete trough that contains four miles of the Lower Rouge south of Michigan Avenue. The wind was blowing gently from the southeast. You could have sat perfectly still in a canoe, and it would have sailed slowly up the Rouge on that day.

Piece of cake, I thought.

Pat and I each had a list of things to bring (see appendix B). We brought waterproof bags for cameras, spare clothes, gloves, a first-aid kit, notebooks, and other things. I brought a hard plastic case for my digital audio recorder and cell phone. The night before we left, I loaded extra clothes, sunscreen, notebook, and pencils into a waterproof bag. We each measured off one-foot increments on six-foot-long broomsticks. They would be our depth indicators and might also be good for poling the canoe.

"It will be interesting to see if we're still speaking to each other by the end of next week," Pat said, as more of the reality of the trip sank in. Her comment was an intriguing way of putting a question we had both been thinking about. True, we had worked together on journalistic assignments, and beyond that, we'd sailed and even raced together on my Lightning sailboat. But although we'd teamed up before, we'd never been cut off from the rest of the human world, dependent on our own resources as a team facing an unknown and potentially dangerous challenge. If things went wrong, if tensions got out of hand, if we failed to work respectfully with each other, then yes, we might wind up on less than speaking terms. It was worth thinking about

and worth making an effort to see that things didn't come to such a pass.

On Sunday, June 5, I was not feeling satisfied with our foot gear. We each had obtained a pair of chest waders for an extreme situation. But for daily non-extreme wear, I didn't trust tennis shoes or my rubber-toed sailing shoes for the rough going I anticipated. So, the day before our trip, I went to a big-box discount store and bought size 8 and size 11 hip boots.

By late afternoon, I had everything packed. On Sunday evening, I made two tuna fish sandwiches. I put an extra dash of pepper in the mix.

At 8:00 that night, Plymouth Township was totally still. Not a breeze. Fifteen minutes later, the tops of our pine and maple trees started waving wildly. A seventy-mile-per-hour wind tore a huge limb off a maple in our backyard. As it plummeted to the ground, it tore down two bird feeders and then crashed across half of the deck. Torrential rain followed. The electricity went off. The power stayed off until 5:30 AM.

Pat called during the storm. As we talked about the next day's adventure, I wondered how much damage the maple limb had done to our deck and worried that the power outage would somehow screw up our start. We agreed to meet at Fair Lane at 7:00 AM. We'd leave one car there and then drive together in the other to Delray Park, where Al Heavner and his assistant, Nancy Yipe, would meet us with an eighteen-foot canoe. We had already chosen the long canoe for better stability in the Detroit River and the wide Lower Rouge chan-

nel. In case we were lucky enough to paddle beyond the dam at Fair Lane in one day, they'd pack the fifteen-footer we planned to use for the remainder of the trip. The shorter canoe would be lighter when we portaged around logjams and more maneuverable in the tight turns we imagined we might encounter.

I hung up and rummaged through a basement closet with a flashlight to find a pair of battery-operated lamps we keep around for power failures, which aren't uncommon in our neighborhood. By the light of the twin fluorescent tubes in a Coleman lantern, I fine-tuned my packing. I had set up a small shelf in the garage where I'd collected my gear. I went over our checklist. I also wondered what this storm would do to our plans. Not only were we hit with heavy winds but the deluge lasted long enough, it seemed to me, to start some flooding on the nearby Middle Rouge that could send a pulse of high water on to the Main Branch. If other areas were hit just as hard, we could be facing one of those flash floods we'd been warned to avoid, and right at the beginning of our trip.

Oh boy! I tried to imagine what a colossal inundation would be like, and I knew it could force us to postpone our launch. That would not be good. Pat and I had talked about this possibility. Everything was set for this week. It is a serious flaw in the newspaper business that plans often must be made indelibly, with little wiggle room. Sure, in theory we could cancel Monday and try for Tuesday, but what if one of us were sent on a different assignment that called for several days of commitment? Making everything converge again on a new launch date could be hard.

What with the fierce storm, the power failure, and all these worries bouncing around in my head, I couldn't sleep, and I lay awake for hours. When I finally dozed off, I dreamed that I was on my way to meet Pat and the Heavner canoe people, and I got lost somewhere in Detroit. By the time I found them, we were way too late for our start.

I woke up to a peaceful, cloudless day. Despite my poor night's sleep, I felt alert and exhilarated. The prospect of canoeing the Rouge was exciting. All these months of planning, and finally, this was the day! I made a final check of my equipment, including many things—bungee cords, bird book, and extra ropes—that I ended up leaving in the trunk of my car. Somehow, I forgot to eat breakfast.

I took Hines Drive with the idea of seeing how high the Middle Rouge was after the night's downpour. The stream and a big pond called Newburgh Lake were still. No current was even detectable. The Middle Rouge is the branch of the Rouge that kindled my interest in the river system two decades earlier. A few years ago, Wayne County's Department of Parks and Recreation had tried to set up a canoe livery on Newburgh Lake, and it also tried to hold a triathlon there. But the swimming portion of the race was canceled, and so was the canoeing, all because of sewage pollution in the river considered too unhealthy for human contact. Only later did I learn that during the very week Pat and I

canoed, the water from Newburgh Lake was tested, and too many colonies of *E. coli* were found for it to be considered safe for swimming.

One indication of flooding is whether Hines Drive is open, since it's on the floodplain. Actually, Hines Drive was intended to flood. The idea was to put a park alongside the river to prevent the land from being used for housing—homes that inevitably would be flooded during a big storm. I've seen the two-lane blacktop itself turn into a violent stream after heavy rains, but today the Middle Rouge was placid. Hines Drive was dry and open to traffic.

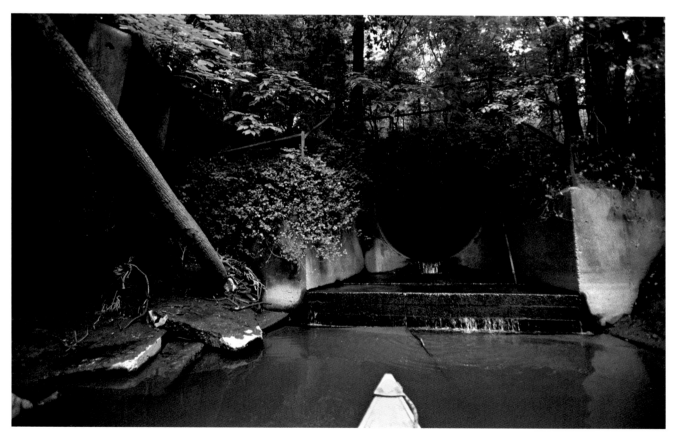

This Detroit drain is quiet now, but its size suggests that it spews a huge gusher of water during heavy rains.

Meanwhile, over the weekend, Pat had planted six flats of pink and white impatiens in her garden and laid down some mulch. She made a trip to REI, the sporting goods store, and bought a pair of convertible pants. Sunday evening, she packed her gear in the trunk of her car using the checklist we'd put together.

In the morning, she stood at her kitchen counter eating yogurt and drinking orange juice. She fed her two cats, Benny and Rose, cleaned the litter box, and took a shower. She made her peanut butter and jelly sandwich, took frozen water bottles from the freezer and packed them in a soft-sided cooler, grabbed cameras and film, and headed for her car.

Pat and I waited at Delray Park at 7:30 AM. Nancy Yipe called right about then to say she couldn't find the park. It's actually just a tiny boat ramp tucked between the former Detroit Edison Delray Power Plant and old Fort Wayne, so it's not surprising that she was having difficulty. Our phone directions helped, and by a few minutes before 8:30 AM we had the canoe in the water and loaded.

Pat had three cameras, several lenses, and a bag of film, and together we had the two sets of chest waders, two pairs of hip boots, rain gear, extra clothes, maps, binoculars, lunch bags, note pads, pencils, lots of bottled water, a spare paddle, two life jackets, and that pair of six-foot-long broomsticks for measuring water depth.

We finished positioning things in the canoe, put on our life jackets, and looked at the river. Things had changed again. The early morning calm was gone. The wind was up. We would be paddling through big white-cap-flecked waves. There was nothing we could do about that. We weren't postponing this trip after all the planning and great expectations. Pat stepped into the canoe and sat down on the forward seat. I sat on the stern seat. We pushed our paddles against the concrete ramp and dug them into the calm water of the boat launch, a little slot on the bank of the river.

This was it. Months of planning, organizing, and selling editors and colleagues on the importance and uniqueness of this project. Finally, we were on the water. Our canoe pitched as we took the first waves. The steel seawalls seemed awfully high—no way to climb up them in case of a capsize. We waved good-bye to Nancy and Al and immediately focused on the task—keeping this small, heavily loaded vessel above water and headed for the mouth of the Rouge. Sure, there was wind, but the day was young and it would subside, or we'd soon be shielded by the banks of the Rouge. No turning back at this point.

Nervous, excited, we paddled downstream, wondering whether we'd make the Henry Ford estate in time to break for lunch.

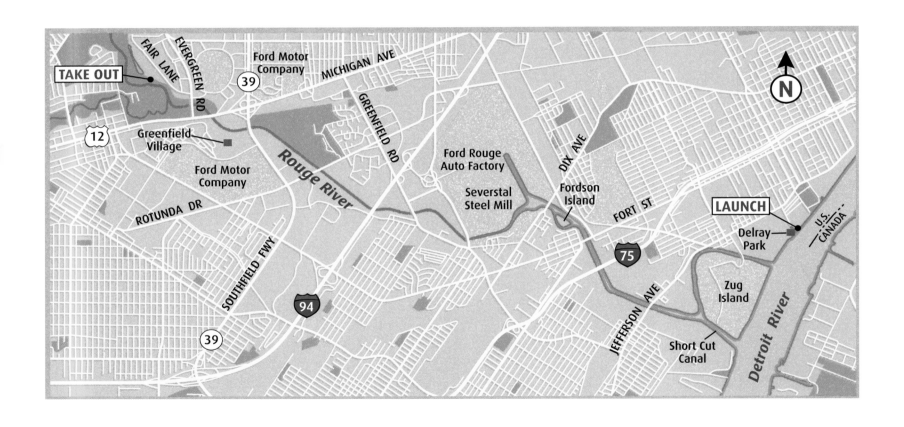

DAY ONE WIND TUNNEL

8:25 AM

We paddle away from the dock at Delray Park, Detroit Edison's public boat ramp on the Detroit River, about a half mile north of the natural mouth of the Rouge River. We nose the canoe away from the sheltered ramp into twelve- to eighteen-inch swells flecked with white-caps. According to the National Weather Service, at 9:00 AM the winds are blowing ten to twenty miles per hour from the south-southwest. In the afternoon, the gusts will reach thirty miles per hour. To keep from running over fishing lines slanting toward the water, we head away from shore. Our little canoe bobs on the swells. South of us a few hundred yards we see the outline of Zug Island with the bulbous black blast furnaces of the United States Steel Corporation mill.

Our aim is to head into the old river channel just north of Zug Island. The main shipping channel is the so-called Short Cut Canal connecting the Rouge to the Detroit River around Zug Island's southern end. We want to avoid that.

"There's no shipping in the natural channel," I shout to Pat.

But now, as we wallow in the chop, both of us notice something ominous. It looks like a small black rectangle, but it is getting bigger. Coming north past River Rouge, south of Zug Island, and hugging the west side of the Detroit River, the flat front of a barge appears to be heading straight into our path.

Correction: We are right in its path.

Where is it going? Maybe the captain is asking his mate the same thing: What's that damned canoe doing? That is, if he can even see us. The Detroit River proceeds south toward Lake Erie at a seven-mile-per-hour clip. The barge looks to be making the same rate going upstream. As it comes closer, we see that it and its cargo of one semitrailer are being pushed by a tugboat. Again we wonder what the chances are that the tug's skipper can see us. Nothing to do but for Pat and me in our little canoe with its scant four to five inches of freeboard to brave the swells and stand out in the river until this

1

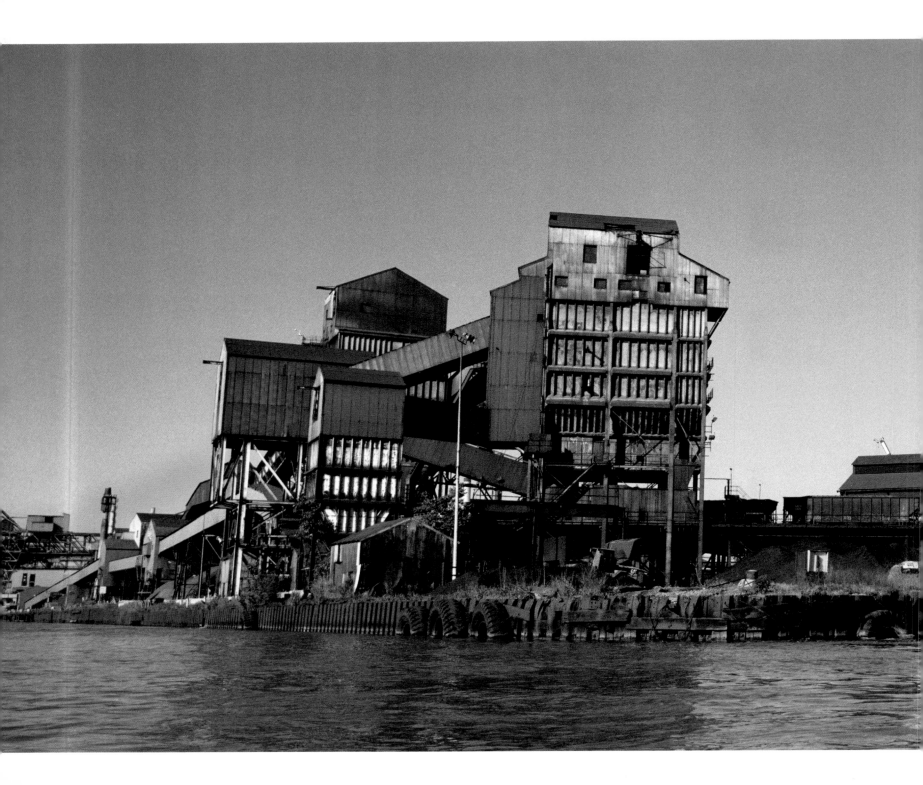

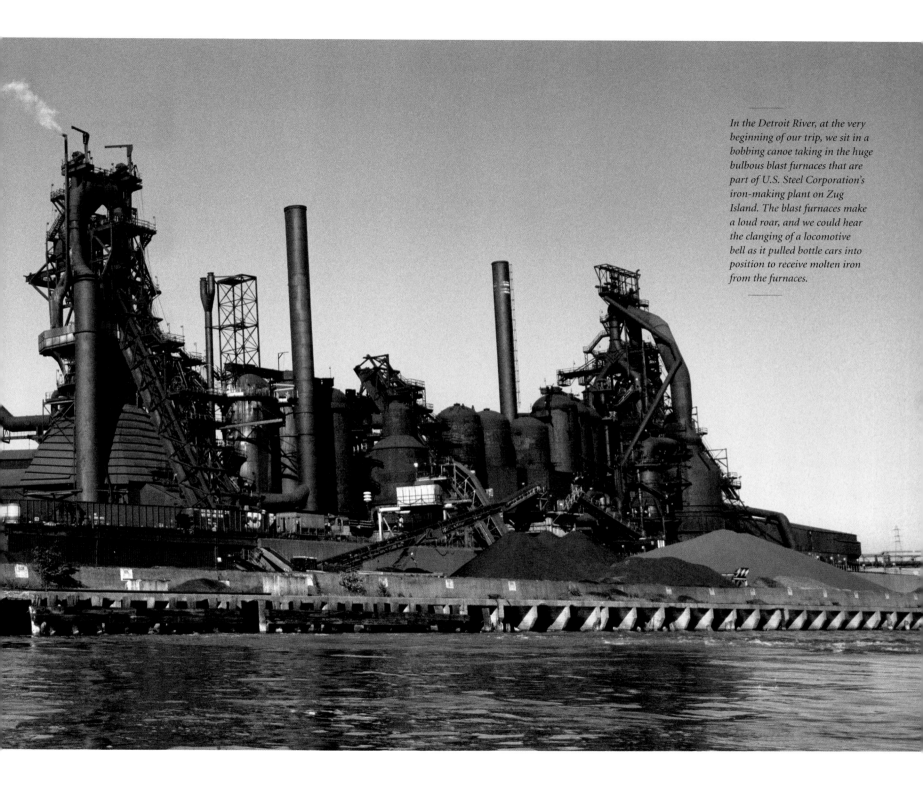

In the Detroit River, at the very beginning of our trip, we sit in a bobbing canoe taking in the huge bulbous blast furnaces that are part of U.S. Steel Corporation's iron-making plant on Zug Island. The blast furnaces make a loud roar, and we could hear the clanging of a locomotive bell as it pulled bottle cars into position to receive molten iron from the furnaces.

behemoth passes us. Some distance away, there is possible shelter—a tall steel seawall. But we worry that the seawall is the barge's destination. This little metal shell we are paddling could be crushed, with us in it. So we stay out in the river and wait.

"Don't worry, Pat. We can scoot into the Rouge—they don't use that channel."

By now we are beside the barge. It is between us and shore. The guys on the tug don't know they aren't supposed to turn up the old river channel. They do just that, and dock the barge near the corner where the Detroit and Rouge rivers meet, at the LaFarge cement plant opposite the northeast tip of Zug Island. (Later, I learned that the barge and tug belong to the Detroit-Windsor Truck Ferry, which carries hazardous manufacturing materials between Canada and the U.S.) Rapidly, the tug powers the barge sideways toward the wharf, leaving room for us to paddle into the Rouge under the blast furnaces of Zug Island. We wait long enough for Pat to take a wide picture of the tug and the Zug Island blast furnaces. Then, we dig in with our paddles and drive the canoe across the turbulent green and white waves roiled up by the tug. Soon we are in peaceful water, with tension and crisis behind us. For the moment.

8:36 AM

We are sitting right under the blast furnaces of Zug Island. When you're driving toward Detroit on Interstate 75 and crossing the bridge over the Rouge, you can look to the right and see these three black, awkward-looking structures that are the U.S. Steel blast furnaces. From such a height and distance, the Zug Island landscape always conjures up a fantastic or science-fiction-like sensation. But from a canoe, floating near the Zug Island wharf, the furnaces look like huge black jugs with rickety conveyors leading skyward to their mouths. Unless you're on some kind of VIP tour of the ironworks, you won't get near these roaring iron-makers—that is, unless you approach them by boat or canoe. So, it was impressive to be sitting in a canoe almost under these furnaces, which have been turning out iron since the early twentieth century. Nowadays, when I look at my car, I think how most of it was produced in huge, hot, noisy structures like this. What an amazing sight.

The water is still choppy here at the Rouge's mouth.

8:40 AM

We're still under the blast furnaces. Pat again shoots a panoramic photograph of Zug Island at the north end of the city of River Rouge. Pat shoots pictures, and I talk into my digital audio recorder, but every so often, there is an abrupt halt in the narrative because I have to stop my chatter and go back to paddling. I don't have a voice activator on the little recorder that hangs from a loop around my neck.

We're seeing big billows of steam, a train moving to a blast furnace. We're hearing the engine bell clanging incessantly and the constant roar of the blast furnaces.

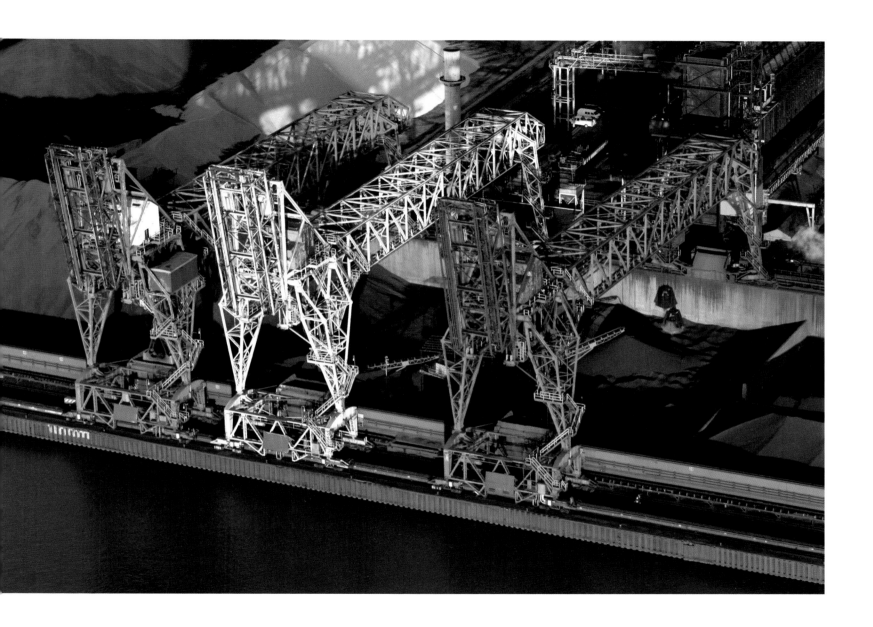

8:45 AM

I am now hanging onto a tire tied to a cable tied to a barge on the north side of the Rouge. Pat takes panoramic pictures of Zug Island. Each time she changes cameras, she puts the unused camera into a waterproof bag, so if we capsize, only one will be immersed.

The blast furnaces dominate the landscape. Cog elevators lift coke high to the tops of the furnaces. Huge billows of white gas rise from the furnaces. Heaps of slag are piled on shore. We still hear the regular clanging of a railroad engine bell. The engine is waiting for molten iron to be poured from the furnaces into bottle cars. This plant's product goes for a couple miles from Zug Island in the city of River Rouge, where iron is made, to the city of Ecorse, where the steel is rolled into coils and shipped to manufacturers.

Pat takes more panoramic pictures. It is hard to steady the canoe—we have a strong wind coming straight at us down the natural course of the Rouge, so even though the current is backed up and is actually the Detroit River going up through its natural course, the west wind is making it a little hard to position the canoe. On the surface of the water, it looks like wood chips and detritus may have floated downstream from last night's storm in western Wayne. Pop cans bob in the water with our canoe.

An old cabin cruiser, surrounded by all sorts of metallic junk, sits high and dry above the Rouge River in the Detroit community of Delray opposite Zug Island.

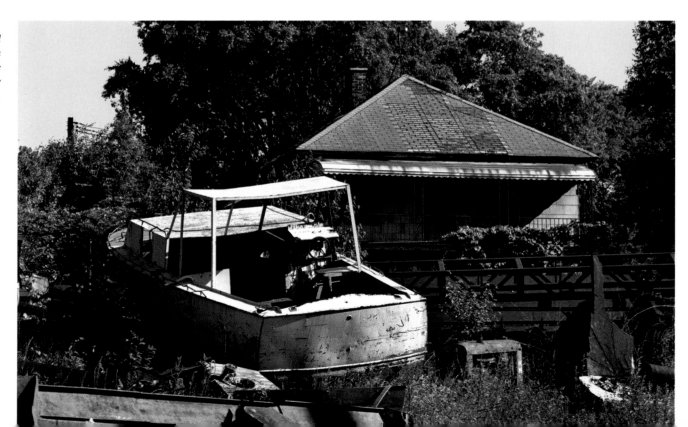

8:53 AM

I am holding onto another docked barge now, my right arm looped around a cable, as Pat takes pictures of the Delray Connecting Railroad Company's green drawbridge. We admire the bridge's big counterweight. The sky is a deep blue, and except for the wind, the weather is fine. The breeze is at least keeping us cool.

"Ready to go?" I ask Pat.

"Yes," she replies.

8:55 AM

We are sitting still again. Sort of. The current pushing up from the Detroit River is countered by the wind pushing the opposite way. I try to steady the canoe as Pat shoots another picture of the bridge. We are slowly coming up to this green bascule bridge. A bascule bridge is a drawbridge that uses a set of gears, an electric motor, and a huge concrete counterweight to raise the "leaves" of the bridge, so freighters can pass up and down the river.

"Can we go left?" Pat asks.

I paddle on the right, steering us left for a better shot of the bridge. We see the monster concrete counterweight. No one appears to be in the control tower. While still approaching the bridge, we go by some huge ironclad pilings fifteen feet in diameter. To the right,

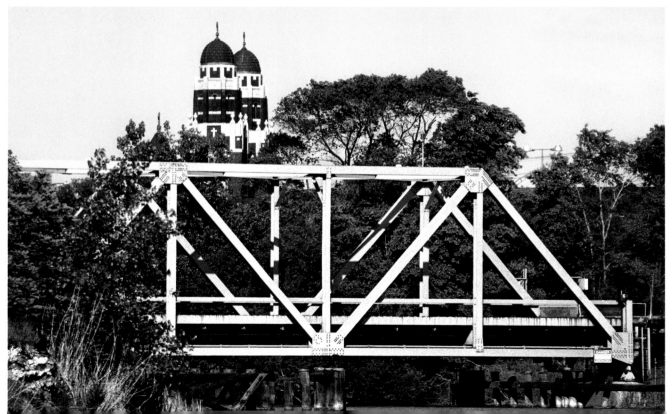

The Delray Connecting Railroad swing bridge serves the U.S. Steel iron-making plant on Zug Island. St. John Cantius Church, whose twin towers are seen in the distance, once served a large and thriving immigrant Roman Catholic community. Today, its neighbors are big settling ponds for Detroit's wastewater treatment plant, not visible from the Rouge River.

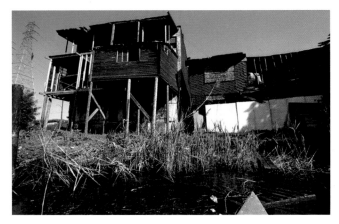

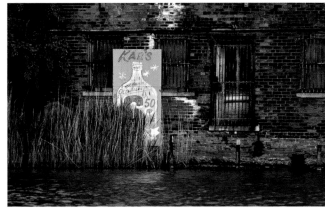

We float by a dilapidated building that we learned later had been Kar's Tavern on West Jefferson Avenue in Delray.

An old painted wooden advertising sign hangs from the river side of a brick building with grated windows and doors. Later, we learned that this building once housed the Kar's Bottling Company.

we notice what looks like a burned-out generator plant. We hear train horns and the roar of the Zug Island blast furnaces. We are now forty to fifty feet from the bascule bridge. We see trucks going back and forth on it. Beyond the bridge on the river's north side, we spot huge metal cans that would dwarf fifty-five-gallon drums. They look like they've been torched apart.

9:09 AM

Pat takes pictures of the big gray and brown cans. Like many things we will see, the purpose of these cans is a mystery to us, and all the more so because they seem to be in the process of destruction.

We then paddle toward the water intake for the Ford Rouge plant. Water is piped from there under Dearborn Street to the auto plant.

9:14 AM

We are still approaching the Ford Motor Company water intake at the foot of Dearborn Street. Birds are singing. A train rings its bell and blows its horn. South of the Ford water intake, we see a veritable junkyard of old cabin cruisers and scrapped metal tanks.

9:25 AM

A green, red, and cream tugboat and a big old crane with a couple of barges are tied up just east of the Ford water intake. We see lots of old lumber and rank growth of bushes and weeds. It's wildlife habitat in a junkyard. A tattered American flag flaps in the wind. We pass twelve-foot-high heaps of slag on Zug Island. On the banks of the island, we see cast-off bricks from the blast furnaces and stoves. To the north, we see the twin spires of St. John Cantius Church. Alongside the

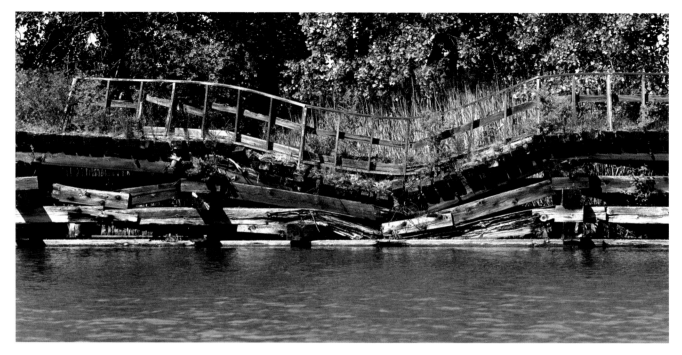

A wooden walkway is partially collapsed along the natural channel of the Rouge River in Detroit across from Zug Island.

bank is what we take for a tall, ramshackle house that appears abandoned. Not far away, we see an orange brick building close to the river. On it an old sign still shows a beverage bottle and the word "Kar's." From nearby reeds, a grackle scolds us.

A couple months after our canoe trip, I stopped for lunch at Kovacs' Bar in Detroit's Delray neighborhood, just down Jefferson Avenue from the ramshackle house and the orange brick building with the Kar's sign facing the river. I showed Pat's photo of the building and sign to Bob Evans, owner of Kovacs' Bar. "That's the old Kar's Bottling Company," Evans said. What Pat and I took for an abandoned house actually was Kar's tavern, with a view over the Rouge and Zug Island.

9:32 AM

We paddle toward the Zug Island swing bridge, also painted green. We see what looks like a huge bicycle chain wrapped around a big cog-like drum, or turret, that is the means of turning this railroad bridge. Nearby are power lines carrying electricity to Zug Is-

land. We can still hear the roar of the blast furnaces. The wind coming around the north side of Zug Island is very stiff. It is hard to keep the canoe in place as Pat shoots pictures.

9:52 AM

We're still on the north side of Zug in the wind, fighting to keep in place whenever we want to stop. Coming up are big piles of gravel on our right and Zug Island's great black mounds of slag on our left. Zug Island is lined with slag and lots of old bricks from the iron blast furnaces. It looks like an archaeologist could have a lot of fun digging here. More than one hundred years of rubble is built up on what once was marsh.

On our left, we see two swans. They slowly swim away from our canoe. Then we think we've spotted a loon. Wow! A loon on the Rouge? We are excited.

"Oh, it's not a loon!" Pat sighs.

It is a goose.

Pat tries for photos of the swans, but as we approach, they head away. We see a great blue heron. It sees us too and takes off. Pat snaps a picture but doubts that she got anything. The tall bird came into view and took flight too fast.

It is a job to keep the canoe steady while Pat changes lenses, cameras, or film. Tippiness is a bad thing when she is moving a lens out of a watertight bag and onto a camera body. She does not always appreciate my efforts to steady the boat. Pat chides me after a wobble scares her: "Think of it like a dance," she starts to say to me.

"If you move really—"

"I'm trying, Pat—I've got current going one way and wind going the other way."

We keep trying for the swans. Eventually, they push hard and are suddenly flying out of sight.

10:11 AM

We are moving slowly around the west end of Zug Island, where the Short Cut Canal to our left meets the natural channel that we have been paddling in. The Lower Rouge comes to a fork at Zug. Upstream, the Lower Rouge leads northwest toward the suburbs. The wind is fierce here, and I notice a new hazard: a freighter tied to the south bank of the Rouge. It is the *Crestar* from Luxembourg. This time, the boat—ship—that threatens us is motionless. My worry, nevertheless, is that this headwind that keeps hitting the bow of our canoe will twist us off course. I am afraid we'll bang into the freighter and capsize.

We paddle hard. Harder. Even harder. We come close to the bow of the *Crestar*. It is near our left side. Both of us are sweeping, sweeping with our paddles, and the freighter finally drops astern. We make it by.

We keep paddling hard. Now it is a matter of picking the easiest passage by trying to read the surface of the river. Wherever the wind ripples the surface is where we don't want to be. The best place is to be in the lee of the south side of the river. The wind is weaker here.

To get out of the path of an outbound barge, we held onto the concrete dock at the U.S. Gypsum plant. A small tree has taken root in a crack between the concrete wharf and an aged wooden fender.

10:30 AM

We watch an eighteen-inch drain gushing water from under a slag pit a couple hundred yards east of Jefferson.

"Pretty bridge," Pat observes. I look up and see the twin-towered Jefferson Avenue drawbridge.

"Isn't it pretty?" I reply. I like drawbridges.

The roar from the blast furnaces is still very loud. It is a constant noise. In the direction of the West Jefferson drawbridge, we hear the clatter and honking of cars. We're noticing that the water in the natural channel of the river is green, as in the Detroit River. The

Water pours from a plastic drain tile into the Rouge River in an industrial area of Detroit. Nearby a wild iris grows at the water's edge.

water in the Rouge itself and the Short Cut Canal is brown. That's because the Detroit River forces its flow up the natural arm of the Rouge, while the main thrust of water pressure from the Main Branch of the Rouge goes fairly straight down the Short Cut Canal to meet the Detroit River.

We travel farther, through branches and flotsam that may be from last night's storm. We still hear the roar of the Zug Island blast furnaces. West of the Jefferson bridge, we hear loud traffic noise. We are still having trouble with the headwind. The current has not been a problem for us, but the wind is another matter. I think how just a week earlier, I stood on the Rotunda bridge in Dearborn and watched an east wind blow up the river. Had we been on the water that day, we would have sailed upstream toward Henry Ford's Fair Lane estate. Not today.

We are surprised how noisy the river is. Between the wind buffeting our ears, the roar of the steel furnaces, the traffic, and the scolding birds, it is loud.

10:45 AM

I notice some activity upstream. It is yet another bridge—the railroad drawbridge between Jefferson Avenue and Fort Street. It is going up.

"Hey, Pat! Maybe they're raising it for us!"

Ha ha. We look up and down the river. We are about to have company again. The wind blows grit from the nearby U.S. Gypsum plant into our eyes. What timing. We see what looks like the bow of a freighter coming

through the space opened by the railroad drawbridge. It is headed right toward us. As for the barge, the questions again are where exactly is it going to go and does it see us?

"We're gonna have to watch out for that baby," I say to Pat. To our left is the wharf of the U.S. Gypsum Company. We paddle to its east end, and I grab a piece of steel reinforcing rod that juts out from the concrete dock.

"We'll just sit here and let them go by."

"I wonder if they want to dock where we are," Pat muses.

I hold onto the little piece of re-rod and poke the bow of the canoe out so we can see a little better. The vessel grows bigger and bigger as it approaches. Now we can see that it is not a freighter. It's another barge, being pushed by a tug. Men in life jackets prowl the deck. We sit, waiting, hoping that they don't want to dock where we are bobbing beside the wharf. We see the men look at us. Finally, we can tell that they are not coming toward us but heading toward the Jefferson bridge. As they head down the river, the tug comes into view, blue on top, white in the middle, and black on the bottom. It is the *Karen Andrie*, owned by Cleveland Cliffs, a mining company.

The dust is worse now. It is in my eyes. I blink and blink. Pat is shooting, but I see a line of wind coming at us, riffling the waves. My own wind-speed indicator from many sailing trips is that whitecaps show up when the wind hits thirteen miles per hour. So, into my

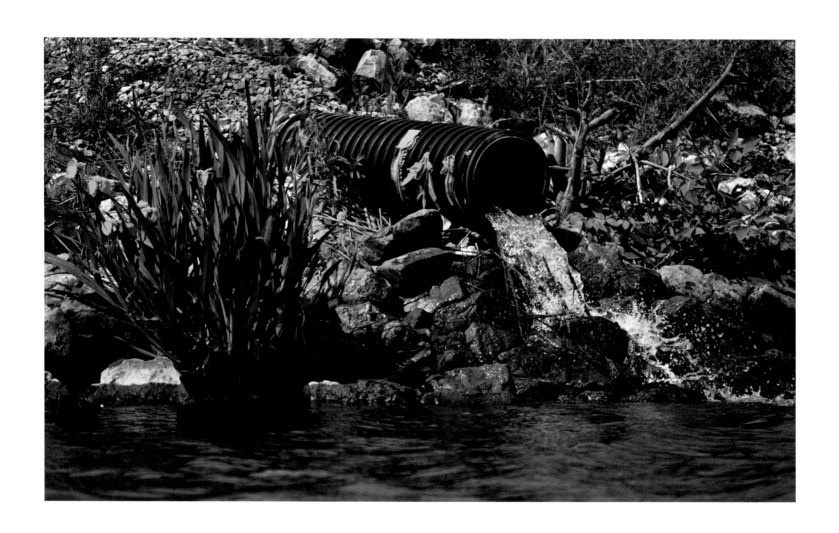

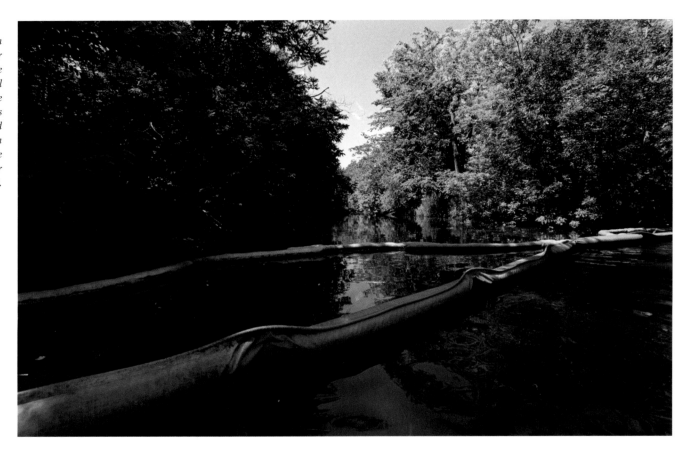

Floating booms block access to a drain leading to the Rouge River near Interstate 75 in Detroit. We learned that these booms—still present in late 2007—are intended to contain oil that spills from the combined storm and sanitary sewer overflow from the Detroit Water and Sewerage Department's wastewater treatment plant.

digital recorder I estimate the wind velocity at twelve to thirteen miles per hour. Later, when I talk to a meteorologist at the National Weather Service, I will learn that gusts are actually hitting thirty.

"There is still quite a bit of wind," I say for the audio log.

More company now. Men in hard hats from the gypsum company have appeared on the wharf.

"Can we see some ID?" one asks. "What are you doing at our dock?" They mention things like "Homeland Security" and "9/11."

I pull a plastic bag from my pants pocket and show

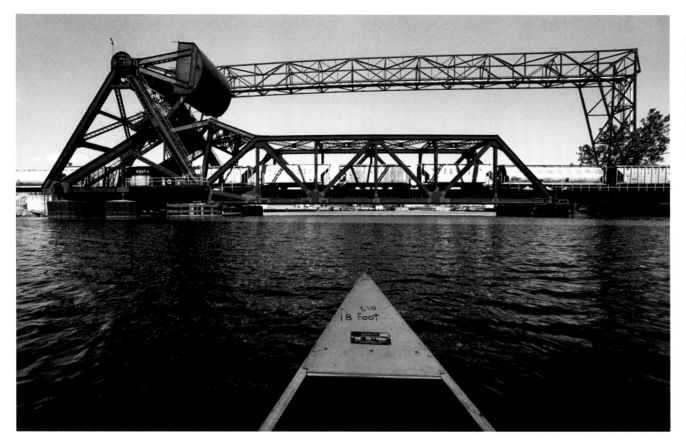

A train crosses the Norfolk Southern railroad drawbridge over the Rouge River as our canoe approaches. The bridge raises for freighters and other large vessels that come from the Detroit River up the Rouge to reach industrial docks farther upstream.

them photocopies of my Michigan driver's license and my *Free Press* ID card. I'd been warned this might happen. Dorothy Zammitt, co-owner of Lockeman's Hardware, less than a mile from here, had urged me to notify the Coast Guard, Border Patrol, Wayne County marine patrol, and U.S. Steel that we'd be in a canoe taking pictures.

"They stop people for less than what you'll be doing," she told me. I had taken Dorothy's advice. Sort of. I called the Coast Guard and explained our project, but I didn't call anybody else. I'm a firm believer in the old maxim "Better ask forgiveness than permission."

Tell too many people, and someone might just say no. Besides, the Coast Guard officer had assured me we had a right to canoe the Rouge. It is, after all, a federally protected navigable waterway. Part of it is, anyway.

The gypsum folks look at Pat. They look at me. They look at our canoe laden with camera bags, lunch bags, four sets of rubber waders, and a spare paddle and shake their heads.

"Never seen a canoe on the Rouge before," one says. "Wish we were going with you," says another. "Good luck!" they call to us over a loud droning noise and the constant beeping of a bulldozer.

11:15 AM

Interstate 75 is in sight, and we see a big tanker tied to a wharf. Henry Ford was largely responsible for having the Lower Rouge dredged so it would be deep enough for big ships to move upstream to his Rouge factory in Dearborn. The river isn't very wide though. Small as our canoe is, we are always wary of these big boats, constantly fearing that we might become an accidental target if we're not vigilant.

We are approaching another railroad bascule bridge too. We have just passed under the Conrail bascule bridge to go past the gypsum plant. This next one belongs to the Norfolk Southern Railroad, and it's just beyond the I-75 overpass. Approaching I-75, the roar from the cars and trucks is remarkable. A bulldozer at the gypsum plant adds to the growl. We notice with some amazement how muddy and brown the water is. The bulldozer now adds a high beep beep beep to the noise.

Just before reaching I-75, we paddle by what looks like a creek coming in on the south side of the river. We find a floating inflated plastic gate, or boom, roughly looped to separate the creek from the river. Pat thinks it might be here to contain an oil spill. She's right. In 2002, a plant in Dearborn dumped one hundred thousand gallons of oil into the sewer. The oil reached a wet well connecting various arms of the sewage collection system, where it overflowed into the O'Brien Drain. What we're seeing, with its mouth partly blocked with the inflated boom, is the O'Brien Drain outlet to the Rouge. The boom is still there three years after the big spill because oil and other pollutants continue to discharge from this creek.

At this small, murky confluence, we see a blue heron fishing. It takes off at the sight of us. This is the filthiest water I've ever seen. We could not begin to see to the bottom of it. It does not stop beautiful wild yellow irises from growing along the bank, however. The booms we pass look like they're made of canvas or rubber material.

We paddle under the I-75 bridge, feeling a slight headwind but drifting upstream anyway. We listen to the traffic. Over the racket, a bird seems to angrily scold us, cheeping insistently. Now a train adds its noise to the bedlam. It's on the Norfolk Southern bridge ahead

of us, and it's a long one. We hear bells from the engine and the rumble of railroad cars.

11:45 AM

Coming out from under the I-75 bridge, we continue to watch the train cross the Norfolk Southern railroad drawbridge. We decide to wait, not wanting to pass under moving rail cars. What if something would fall off? Many of the cars are carrying liquefied petroleum gas. The train goes on and on.

Last night's windstorm hit Plymouth Township, where I live, with gusts of more than seventy miles per hour. Because of the wind, rain, and power outage, I didn't sleep well, and in the morning I left the house in a hurry, with no breakfast. I was hungry now. So was Pat. I could see the Fort Street bridge beyond the railroad bridge. Would this train never end? Car after cylindrical car was going by.

"What do you think?" Pat asks. "Should we go?"

"We're going under it, train or no train," I say.

So, under the rail bridge we paddle, cars clanking and groaning overhead.

"Whew!" We emerge safely on the upstream side.

Very quickly, we paddle under the Fort Street bridge and find a tidy patch of shade. We beach the canoe, and I fish my cell phone out of its waterproof container. This is the bridge that, a few months back, I wrote a story about. I met the bridge tenders, got a tour of the control tower and the underground mechanics, and, most important for this day, came away with the phone number for the tower. Now I punch that number into my cell phone. A woman answers.

"Hi, my name is Joel," I say to her. "I'm a *Free Press* reporter. My friend is Pat. She's a *Free Press* photographer. If you will look out the west window of your tower, you'll see us sitting in a canoe. We're wearing green life jackets."

"I see you!" Her name, she says, is Marlene.

"Can we use your john?" I boldly ask her.

Marlene Mitchell calls her bosses and seconds later calls me back.

"Come on in."

Pat loops our bow line over a piling on the west side of the bridge. We get out of the canoe and climb the bank. Marlene meets us at the door of the control tower. We follow her downstairs to a restroom with an odd toilet. It incinerates what you leave behind—but only if you press two buttons in the proper one-two sequence. When it burns your droppings, it makes a loud roaring noise.

12:53 PM

Back in the canoe, we sit in the shade of the control tower and eat our lunches. The week before, we'd had a little discussion about the nature of a canoe lunch. Pat held that peanut butter and jelly was the best kind of canoeing sandwich. I brought tuna fish. But tuna salad contains mayonnaise. It could spoil in the heat,

A 1980 Michigan boat registration sticker is still visible on the rotting hull of a partially sunken wooden boat at the west end of Fordson Island, on a channel off the Rouge River.

A houseboat, partially sunken off Fordson Island.

Pat countered. Peanut butter and jelly gives you energy. I disagreed. I needed substance. Meat. Now, my tuna didn't taste so good. I had put too much pepper in it. We shared a bar of chocolate and each of us ate a banana, followed by lots of cold bottled water.

Upstream and across the river, we watch men working to repair an old tugboat. It looks as if they have already put a new roof on it. Farther west we see Fordson Island.

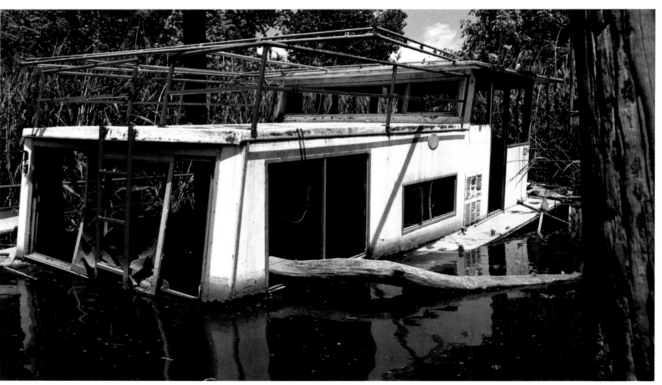

1:00 PM

We leave the Fort Street bridge and paddle toward Fordson Island. It looks like a tugboat alley coming up.

1:27 PM

We count six tugboats lined up at a wharf on Fordson Island as well as three barges and a pair of cranes. The sky is hazy now from grit coming out of the Severstal steel mill, what used to be the Ford Rouge mill. Flags are flying straight out.

"Small craft warnings," Pat says wryly. We are a small, small craft. Dust gets in our eyes. From noon through the afternoon, the wind blows at fifteen to twenty-five miles per hour with gusts as high as thirty, according to the National Weather Service.

Going past Fordson Island, we pass a green two-story house with a radio tower. Near the west end of the island, we explore a channel that leads past dead boats. We see an old boathouse with a sunken boat inside. There are half-sunken cabin cruisers; a cabin cruiser with its seats turned up and the foam rubber exposed; a really old, wood-planked hull and yet another hull, maybe from an old Chris-Craft, the wood all rotty. We spy another ramshackle boathouse, workboats, and a half-submerged houseboat with writing on it: ARS K8OAG STAN. I decode the shorthand: "ARS" stands for "Amateur Radio Station," "K8OAG" is somebody's ham radio call sign, and his name is probably Stan. I take some notes.

Next we pass a cabin cruiser with tall reeds growing out of its middle, its bow all torn apart. I imagine the inboard motors' fuel tanks, containing who knows how much gas, rusting underwater. Pat photographs the 1980 Michigan watercraft license sticker of an old boat whose planks show it was originally fastened together with cheap galvanized nails.

"That might explain why it's all popped apart," I say.

I am an amateur radio operator. My call sign is K8PSV. I recognized "K8OAG" as an amateur radio call sign. After the trip, I looked up K8OAG at www.qrz.com, a directory of Federal Communications Commission–issued ham radio licenses. The call letters were issued to Stanley Busch of Oak Park.

"How it got down there, I have no idea," Busch said of the sunken houseboat. "I used to have it on the Clinton River. I traded it for something else. That would be twenty-five, thirty years ago."

Nine wrecked and partly sunken, wholly forgotten boats behind Fordson Island. We wonder what their stories are. A red-winged blackbird chews us out from shore. Compared to the forenoon's work, it is easy paddling behind Fordson Island, where we see our third blue heron. The place is sheltered by trees on both sides. But it's back to the main river now and more hard work.

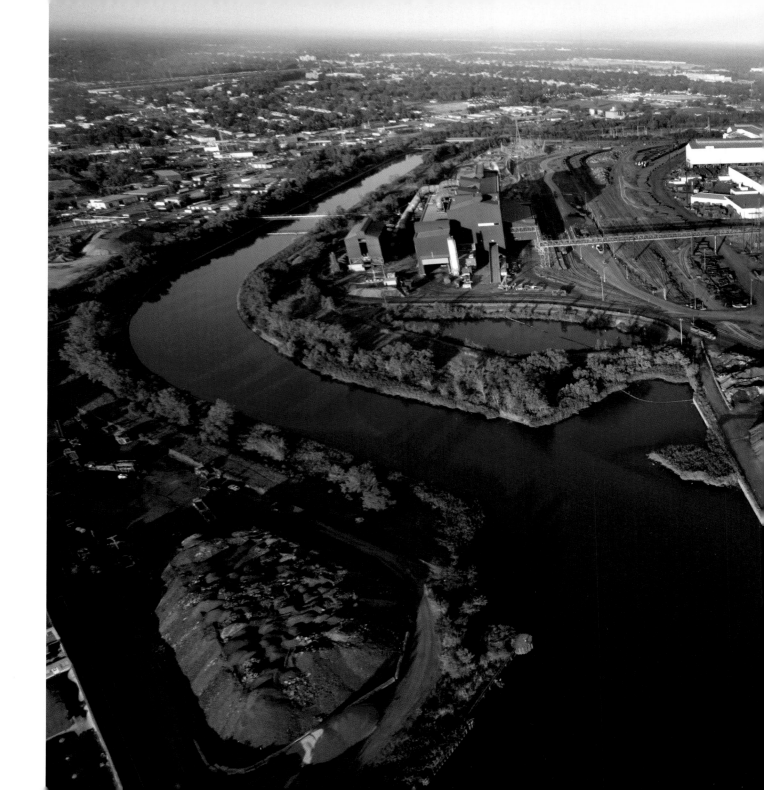

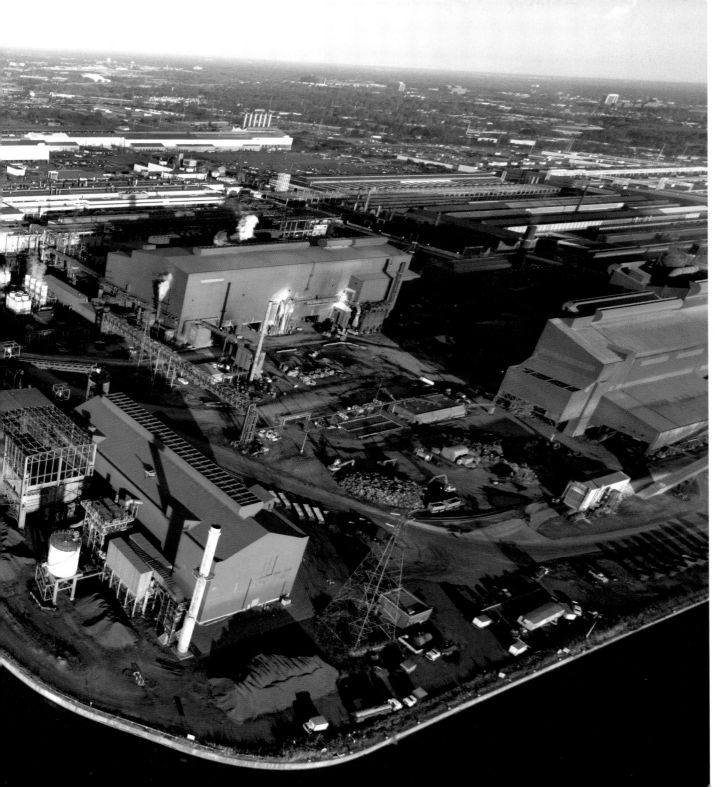

The Rouge River winds southwest around the Ford Rouge (white buildings in the background) and Severstal (orange buildings in the foreground) industrial complexes in Dearborn. In this photograph, the river is flowing down from the upper left. The portion of the river in the lower right is a dead-end channel that serves as the docking area for freighters at the complex. A small portion of the turning basin shows at the bottom. The land in the lower left corner is Detroit; at the top left is Melvindale.

This photograph is an aerial view looking southeast down the Rouge River in Dearborn on Monday, August 29, 2005. The river flows under the Michigan Avenue bridges and a railroad bridge. The channelized part of the Rouge ends just north of Michigan Avenue, at the lower left.

Under the Dix Street bridge, we look up at a big gas tower. It is partly torn apart. This was Henry Ford's creation from the World War I era, a tower that used coke gas from the steel mill to heat and power the Rouge auto plant. It now has rusty, gaping holes.

1:59 PM

Nasty dust is coming at us from the Severstal steel mill. It is in our eyes. I'm blinking constantly. Meanwhile, an increasingly fierce headwind from the west keeps blowing us off course. It is very hard to keep the canoe tracking on a straight line. There is little river current, but the wind keeps pushing us to one side or the other as we cross the turning basin. This is a large turnaround area where freighters that have come upstream to the Rouge plant can turn their bows around and head back to the Detroit River.

"We're looking into the Ford dock, and I'm absolutely amazed that the Rouge plant has such a big docking area," I say into my recorder. "It looks like it's a mile deep. I had no idea they had so much space for freighters." This is the factory complex that Henry Ford built in the early 1900s, so he could bring in iron ore along with coke and limestone and transform them into cars.

We are passing Severstal, the new name for Henry Ford's old steel mill. Russians own it now. We hear a constant roar, apparently coming from the rolling mill on our right.

In a clear plastic container tied to the canoe thwart in front of me, I have a set of topographic maps. The maps show two courses for the Rouge. One is dotted and indicates where the Rouge used to wriggle and roam before people decided to improve it. Those areas are still mostly wetlands, but they no longer receive the river's flow. Instead, the river follows the course depicted by the solid line on the map. That line, while not exactly straight, follows a much less winding path.

By midway through the twentieth century, the Rouge River was changing dramatically. From a meandering, slow-moving creek, it was being transformed into a stream whose flow fluctuated greatly. As the suburbs expanded and more houses, roads, parking lots, and shopping centers were built, stormwater increasingly went straight to the river without being soaked up by the earth. Water levels in the Rouge became a political issue when sewage backed up into homes and businesses at the southern end of the river. This happened because the flooding river backed into the overstressed Detroit sewers.

In 1972, the U.S. Army Corps of Engineers solved the sewer problem. The corps turned the Rouge into a sluice. Former bends of the river were disconnected to create a straighter course for the water to flow down. It altered the river's flow for roughly four miles, from the Ford Rouge plant north to Michigan Avenue.

Not only did the corps iron out most of the curves, but it paved the riverbed. Along this four-mile stretch, the river bottom and banks are made of concrete. The sides slant up high above the river's normal edge. The

concrete trough is 180 feet wide, ensuring that even during floods the river will move steadily toward its mouth at Zug Island without filling basements with sewage.

During the 1960s, Pat had learned how dirty the Rouge could be. Her dad took her in the family cruiser on a little excursion up the Lower Rouge. She remembers drawbridges opening for their boat. They may have gone as far upstream as the turning basin for the freighters. She remembers that there was an oily scum on top of the water. Later that day, she had to scrub the ugly orange and black slime off the boat's hull. In those days, trees were still thick north of the industrial area. Trees would have shielded us from the wind, but the corps had cleared the trees to build the concrete channel.

2:05 PM

We see our fourth great blue heron. It too takes off at the sight or sound of us. Pat can't get a picture. The wind is still coming from the west. The area directly above the river's surface has become a wind tunnel. On the concrete sides of the river, we see dead carp. A dead crayfish looks about five inches long. A big fish jumps near our canoe. Lots of rushes and poplars along the bank make it sort of country-like, except for the orange industrial buildings. The wind hits us hard. My recorder picks up lots of huffing as we paddle to beat the breeze. We notice big piles of slag on the south side of the river.

"When we get done, I want a banana split," Pat says.

"Make mine a Heath Bar Blizzard."

Something underwater swirls up a huge billow of black guck.

2:09 PM

The bottom of the river beneath us is concrete now. We are still passing Severstal. Fish jump a couple more times. We see four or five more dead fish on the concrete banks. They are big dead carp.

We hear noise from a train on our right. Loud booming sounds come from the left, and a constant drone emits from Severstal's rolling mill, also on our right. A big fish jumps near the canoe. A heron takes off and flies overhead. Fierce wind. Another something swirls a huge billow of black guck. We paddle hard just to stay even. We try paddling along the left bank of the river, hoping for some respite from the wind. It works for a bit, but then suddenly the wind catches the bow and turns us out into the even bigger breeze. We cross the river and try paddling on the right side. This zigzagging happens over and over. We are getting nowhere fast.

And it's then that Pat has an idea. Would it be cheating?

"What if we got out and pulled it?" Pat asks.

We have plenty of rope.

"God bless the Corps of Engineers! They gave us a sidewalk," I say.

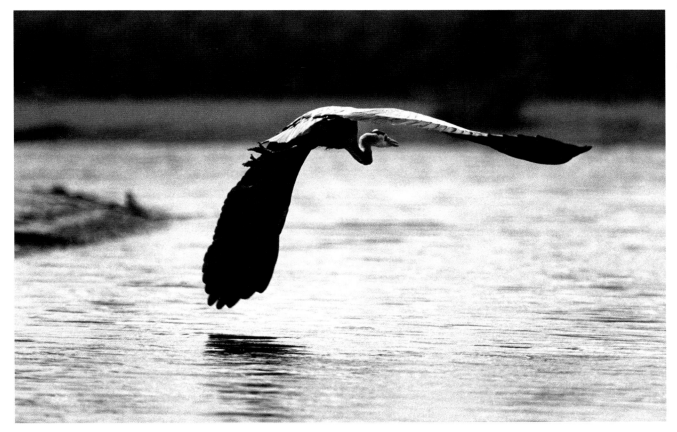

A great blue heron swoops its massive wings as it takes to flight from the Rouge River.

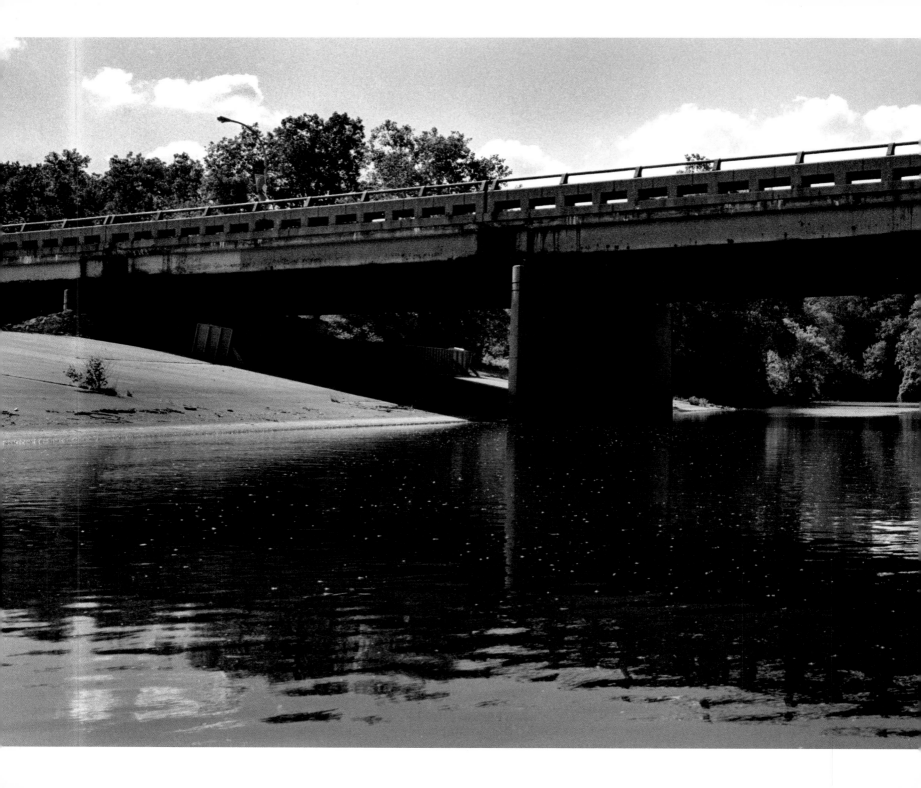

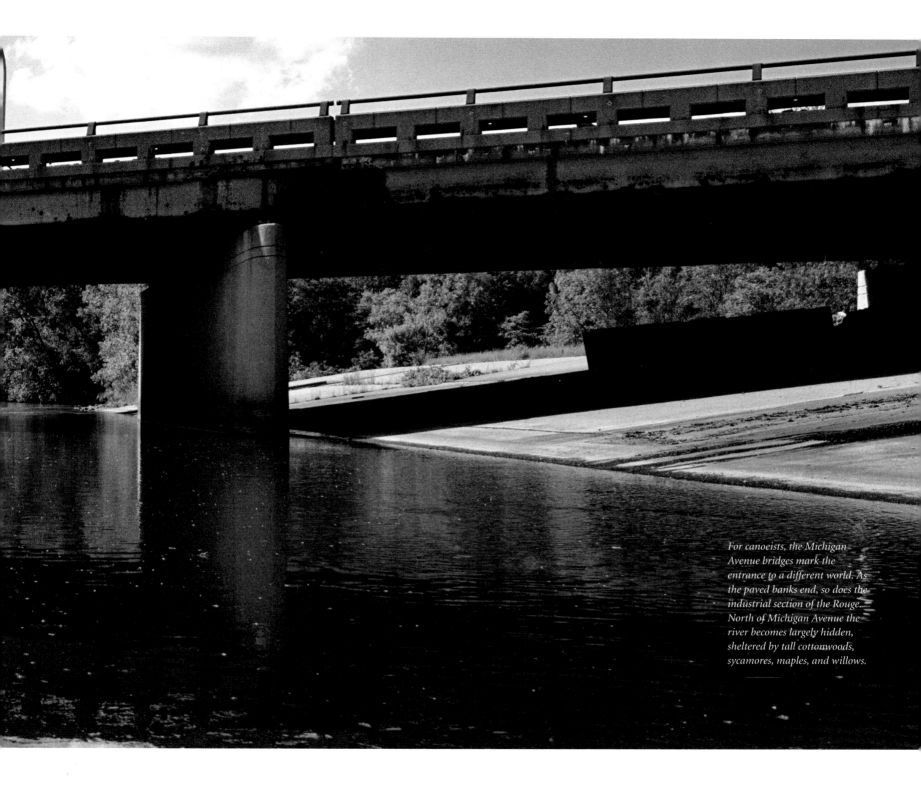

For canoeists, the Michigan
Avenue bridges mark the
entrance to a different world. As
the paved banks end, so does the
industrial section of the Rouge.
North of Michigan Avenue the
river becomes largely hidden,
sheltered by tall cottonwoods,
sycamores, maples, and willows.

I stop and think for a moment.

"Goddamn the corps for straightening the river. They gave us a wind tunnel."

We tie lines to bow and stern and then take turns pulling from the bow with the other person guiding the stern. We are walking the canoe up the Rouge. My "Restrooms of the Rouge" directory shows the Melvindale Ice Arena somewhere ahead. City officials told me it would be open, and it has bathrooms. I am a little surprised we haven't found it already. But it is hard for me to see the map—I'd managed to kick black river muck onto the plastic cover, and I couldn't read the street names.

We smell dead fish. Our sidewalk runs out at the Schaefer Road bridge. We go back to paddling to cross under it. Beyond, our sidewalk stretches ahead. Soon, the wind forces us back to our concrete towpath. Then once again we get back in and paddle under the Greenfield bridge. Plastered to the I-beams are mud nests built in tiers, looking like tiny apartment buildings. Heads peek out of the holes. We drift backward, and I paddle from side to side as Pat takes pictures. They're cliff swallows. When Pat is done, we paddle some more.

3:20 PM

Aha! We spot the public access ramp. We have arrived at the Melvindale Ice Arena. Pat heads for the facilities. I hold the bow line and stand watch over the cameras. They are making our photographic record and are more precious to us than money. I pull my maps out of their plastic sheath. I had all eight of my Rouge main branch maps laminated, so they can't be damaged by water, only dirtied by guck.

As I try to read the map, the wind whips it out of my hands. There goes my map of the Rouge from Severstal to Fair Lane, flapping across the concrete! The canoe is aground, so I drop the bow line and sprint, grab, miss, run some more, and finally snatch up the map.

What a nice, clean, cool men's room the Melvindale Ice Arena has. And bottled water machines! I buy two bottles of chilled water. We already have plenty, but I can't pass up a chance for ice-cold water. My hard-toed sailboat sandals are covered with black slime. Back at the canoe, I look at our waders—two sets of hip boots and two sets of chest waders.

"We were nuts to bring those waders on this part of the trip," I tell my recorder.

4:02 PM

We are towing the canoe. And we regret all these heavy wading boots. Forty pounds of rubber we have along that we didn't need to use today. Now we hear traffic from the I-94 bridge. The wind is blowing straight at us. Pat shoots photos of several geese with the Hyatt Regency Hotel in the background. Our presence scares the geese—a mama goose and several goslings—and they retreat to the water. Pat takes more pictures.

A half mile or so south of Rotunda Drive, hypodermic syringes lie on the concrete. We see several more

dead carp. Wild yellow irises are pushing through cracks in the concrete. On our left is a big new building, the winter home of the Detroit Lions. Ahead is the Hyatt Regency Hotel. Lots of driftwood has piled up on the banks. Eight or ten dead carp and a dead catfish have also washed up.

The concrete channel appears to be bad for fish. It has cut off the water from the wetlands, where flooding used to encourage fish to spawn. Concrete doesn't promote the kind of aquatic plants and small animals that fish need for food. Fish go up the Lower Rouge, but they don't breed there.

In truth, they're not breeding in most places on the Rouge. Although levels of dissolved oxygen in Rouge water now are high enough to support fish (until recently, there was too little oxygen), there are two huge impediments to fish life in the Rouge, I was told by Jeff Braunscheidel, a fisheries biologist with the Michigan Department of Natural Resources. One of them is this concrete channel and the other is the dam at Fair Lane, where the hydroelectric power plant installed by Henry Ford and Thomas Edison in 1913 still generates electricity for the University of Michigan–Dearborn, its present owner. This dam stops fish like salmon (which have been occasionally reported in the Lower Rouge) from swimming upstream to spawn. Several other dams farther up the Lower, Middle, and Main branches of the Rouge also stop fish from traveling. Except for state-planted fish in a pond on the Middle Rouge and

in a tributary far upstream, there isn't a fishery in the Rouge.

I turn on my recorder again. "I'll say it once more—this river is a wind tunnel!"

5:00 PM

We reckon that we are a mile or so from the Hyatt Regency. A blue heron takes off from the concrete. That's a good sign. There must be some live fish here. A quarter mile or so south of Michigan Avenue, we know the historical Greenfield Village is to our left. We can't see it, but we know it's there. Under a railroad trestle, we notice railroad spikes lying on the concrete river's bank. As we take turns hauling the canoe, I make note of the spikes on my digital recorder.

"All kinds of spikes," I report.

"Yeah, all kinds?" Pat laughs. "I'm trying to keep you from being a sensational journalist."

"I see square ones, spiral ones—oh my God, we're going to have to get in the water!" We'd run out of concrete to walk on.

"All kinds!" Pat laughs.

5:24 PM

We are near Michigan Avenue and a couple hundred yards from the end of the concrete section. A definite current is flowing here, though no wind. We have no illusions now about pushing on to Parkland Park in Dearborn Heights. We are both very tired and ready to

call it quits when we get to Fair Lane.

But suddenly, as we pass under Michigan Avenue, we can see a real river. Trees line both sides and shelter the Rouge from the wind. We can't see very far upstream because foliage blocks the view.

5:29 PM

The scenery is no longer industrial. It looks rural. The change is so dramatic, it is as if someone drew a line. The concrete peters out roughly forty yards north of Michigan Avenue. After that, it's a natural dirt-bank river again. Cottonwoods, sycamores, maples, and willows grow all along the river's edge. The trees hang nearly across the river. We notice a little current. We really notice the wind is no longer fierce. It's just a mild breeze. The canoe moves easily as we dip our paddles again. My paddle touches bottom at roughly four feet. We hear some traffic sounds but no more industrial racket. We hear birds. The river is maybe 150 feet wide here.

5:39 PM

We are approaching Evergreen Road, which is not far from Fair Lane.

5:50 PM

We pass the inlet of the Lower Rouge, whose watershed drains Superior Township in Washtenaw County and the Wayne County towns of Canton, Wayne, Inkster, and Dearborn. Not much water is arriving from the Lower Branch. It's not very big. We hear a dull roar.

"Oh!" Pat says. "It's the waterfall."

It is actually water running over the dam at Fair Lane. The dam, which makes the waterfall, diverts water to the powerhouse that Thomas Edison designed to provide electricity to Henry Ford's mansion. Neither of us change our minds about wanting to try pushing for the Dearborn Heights park. We are both hot, tired, and grimy. We are coming to the end of our journey for this day. The waterfall designed by landscape architect Jens Jensen for Henry Ford's Fair Lane mansion is now just ahead. And there is Nancy Yipe from Heavner Canoe standing beside the dam, waiting to load the canoe onto the trailer.

At Fair Lane I ask where we can get a banana split. A while later, the counterman at a Dairy Queen on Ford Road takes orders from two dirty, sweaty, Rouge River canoeists. One banana split. One Heath Bar Blizzard. We'd paddled and hiked 8.9 miles from Delray Park to Fair Lane. We sit outside to eat our ice cream.

Karen wasn't home when I got back to our house. I was exhausted. I walked in and saw, through our living room picture windows, that huge maple bough covering a big part of the deck. It crossed my mind that something ought to be done. I found my chain saw and was busy cutting the maple into firewood when Karen walked onto the deck.

"You must be beat," she said. "Put the saw away, come inside, and take it easy."

I looked at the chunks of maple strewn around the yard. It had been a long day. Enough. Besides, Karen was organizing my sixtieth birthday party for the day after we finished the canoe trip. There were party plans to talk over. I put the saw away. Time for a shower.

I threw my stinky clothes in the washing machine, along with the two filthy ropes. At home in Southfield, Pat entered her house carefully, having peeled off her filthy socks before walking on the hardwood floor. She put her clothes in the washing machine, washed her hands, played with her cats, took a shower, packed the next day's lunch, checked her mail, ate dinner, and went to bed. Each day after she returned from the Rouge, Benny and Rose were fascinated with the new smells she brought home.

TAKE-OUT AT FAIR LANE
9.5 HOURS PADDLED, 8.9 MILES
NO LOGJAMS

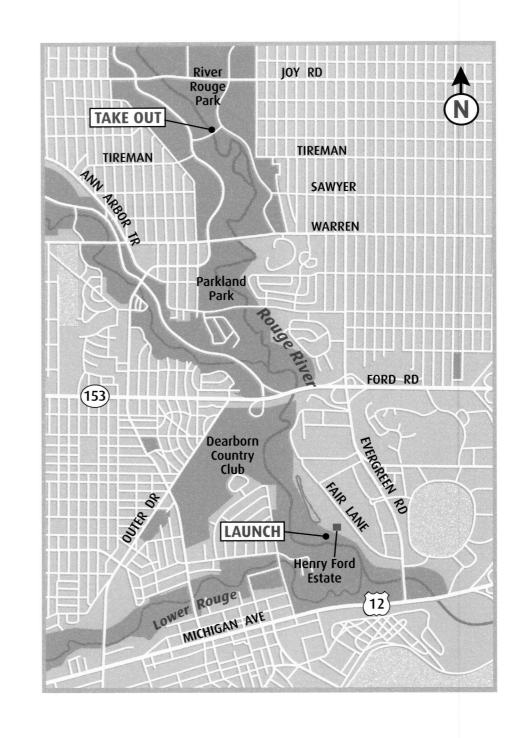

DAY TWO LOGJAMS

10:12 AM

We have pushed off upstream from the dam at Fair Lane, and the splendor of the Henry Ford estate is behind us. Overhead a jetliner roars. The current is sluggish and there is little breeze. It is hot. Humid. We've gotten a late start. It took awhile to unload and launch the canoe, and we are hoping to make up time now. The river I guess to be about 120 feet wide, but it's narrowing as we move away from the millpond. The high this day will be 92, one degree shy of the record of 93 set in 1968. It is fifteen degrees above the normal temperature for this day.

Pat changes film. A heron lands upstream. A downy or redheaded woodpecker flies past. It is a blur of black wings with white patches. The sound of drumming comes to us from the forest. Another woodpecker. With our departure from Fair Lane, I joke with Pat, we have left behind the finest of the restrooms of the Rouge.

Another heron takes off. Several mallards swim ahead of us. A big turtle—a good twelve inches in diameter with a humped back—slides into the river. A musk turtle?

"Big as a soccer ball," Pat judges.

I spot a yellow streamer hanging from a branch. Mark Phillips, the Birmingham science teacher who canoed down the Rouge last summer, told me that he had tied yellow streamers to trace his path. I wonder if this is one of his marks. The river has narrowed to, I'm guessing, sixty to seventy feet. We are paddling around more and more trees. We aren't seeing trash, Pat notices. A big snapping turtle dives into the water. There is a bad smell.

Today we are using a fifteen-foot Michi-Craft aluminum canoe, number 416 in the Heavner fleet, named *The Huron.* We joke that Al will have to rechristen this canoe *The Rouge* once we finish our Rouge voyage. Yesterday we had wanted the eighteen-footer for stability on the Detroit River, and, as it turned out, we needed the stability in some windy places on the Rouge. This fifteen-footer is lighter and both easier and quicker to

turn. We'd been warned that it might be hard to maneuver a longer canoe on the narrow, winding Rouge. While the Rouge is turning out to be not that narrow and winding, we are glad for a lightweight canoe for reasons we could not have imagined before the trip.

Giving us a hand back at the launch was Kris Jablonski, visitor services director at Fair Lane. Kris joked with us that he'd like to take the day off and kayak alongside us. As he helped bring down our gear, he also told us about a rumor that is titillating folks who work in the former Ford mansion. It seems that a woman named Evangeline Dillinger was Henry Ford's secretary. Supposedly, she was the mother of the notorious gunman John Dillinger. According to rumor—and by the way, journalists on canoe trips aren't obligated to check out these things—according to rumor, Evangeline Dillinger lived in a house Ford built farther up the Rouge. That house is still there and still has the boathouse Ford used when—supposedly—he'd drive a motorboat upstream to pay Evangeline a visit. The scuttlebutt at Fair Lane: could Henry Ford have been John Dillinger's father? (Well, I checked it out later and discovered that the secretary's name was Evangeline Dahlinger. Her son, John, was not a gangster but a Navy pilot in World War II who later claimed in a 1978 book, "The Secret Life of Henry Ford," that he was the automaker's illegitimate son.)

Fascinating, the things you hear on the river.

Yesterday we'd had a peek at what we thought might be our first logjam, within sight of Fair Lane. It turned out to be a fallen tree that only partially blocked the

stream. It was no big deal. But it felt like a sign of what is to come. I remember Mark's stories of his encounters with fifty-two logjams between Fair Lane and Civic Center Drive in Southfield.

11:27 AM

Birds are calling. "Here I am—where are you?" That's a red-eyed vireo, but we never see it. Then we hear a ratcheting sound. A flicker? Another big turtle hits the water.

11:38 AM

A basketball floats past us. Tennis shoes. Baseballs. Bottles. A low limb spans the river. We paddle under it. On the east, the bank rises thirty to forty feet and appears to be all sand. Holes divot the sand. The map shows that Ford Road should be less than half a mile ahead. We can see dead wood spanning the river.

We paddle near a stump that sticks up five or six feet out of the middle of the river. Atop the stump sits a beautiful tiny bird. It is bright blue on its back with a brilliant blue cap, and its throat and breast are white. It holds its pose, even with us just a few feet away. Before Pat can get her camera out of its waterproof container, though, the bird flies away. Later, Pat identifies it from a bird book. It was a tree swallow.

The holes in the sand banks are reminding me of kingfisher homes. Later, I learn the name of this place is Kingfisher Bluff.

We come to a logjam that has collected a red fire extinguisher, foam cups, empty bottles, and metal cans,

A logjam has captured a fire extinguisher, beach ball, liquor bottle, and other debris on the Rouge River. This logjam consists mostly of floating logs and debris held in place by fallen trunks of trees. It's evidently been in place long enough for vegetation to sprout on it.

The author guides the
canoe under a fallen tree
on the Rouge River.

and from this mess, invisible to us, a bullfrog croaks. In the air and atop the water are clouds of cottonwood fluff. By the end of the day I am coughing from breathing fluffy cottonwood seeds.

12:06 PM

We paddle under the westbound lanes of Ford Road. Some log-jammed spots still give us twenty to thirty feet of clearance, so we can still get through. This logjam negotiation is turning out to be much easier than we thought.

12:25 PM

We are passing the Evangeline Dahlinger boathouse. The door is partly open, so we peek inside. The boathouse has a rock facade hiding its concrete structure, but the south side has caved in, and dirt has poured into the building.

12:30 PM

We have arrived at our first real series of logjams. The first one isn't bad. We manage to pass through a small opening.

"Smells like an outhouse," Pat says.

12:33 PM

The next one is really a logjam. A cardinal calls *p-tooo, p-tooo, too-too-too-too.* We have a real problem here. A downed tree has snagged tree trunks, an old tire, bottles, and many, many logs.

"Looks like you could walk over it, but I doubt you could—we're going to have to find a way to get around this thing," I say. But neither of us want to unload all our gear, tromp through the woods, haul the canoe over land, and reload it.

12:34 PM

We measure the depth of the water with our six-foot broom handles. The water is five feet deep. We left behind our chest waders today, of course. But the water is too deep for them anyway. We put on our hip boots and life jackets. Pat proposes that we leave our gear in the canoe, loop the bow line around a log in the jam, and then run the line back to shore and loop it around a tree trunk. Using that leverage, we pull the boat over a log.

We are careful walking on the jam. Some logs are solid, but others give way. If either of us steps on the wrong one, we could be drinking a Rouge River cocktail. We turn the jam into an ugly staircase. We shove, pull, tow, and bang the canoe over seventy feet of jumbled logs, lumber, and trash. As we move the boat, we press down with our feet, testing logs and branches to make sure they will hold our weight. Underneath we can see the swift current. We do not want to fall in.

We're pleased that we never have to remove anything from the boat. Near the end, Pat and I inch our way out on a log suspended over the river. We pull the canoe through flotsam, clear of the jam. Our sense of triumph is short though. A hundred yards ahead, we

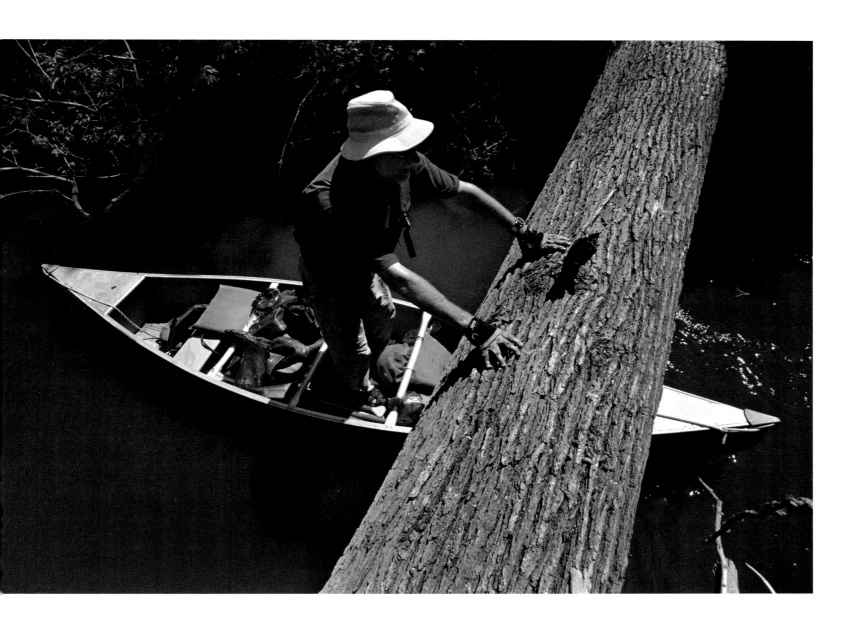

see another logjam.

"We won't call it logjam number 2 yet—for us, it's only a logjam if we can't get through it paddling," Pat says, laying down the rules.

I think, *Take another look.*

"Well, it's a logjam," she soon determines.

Okay, lunch time then: peanut butter and jelly sandwiches, for both of us. We also eat chocolate left from yesterday. We forgot to eat all the bananas from our first day, and they have turned into a yucky mess in Pat's lunch container. Hereafter, no bananas. An idea of Pat's—to freeze bottled water and drink it as it melts—is working great.

1:27 PM

The hip boots are making my legs hot. Pat takes hers off. She can't stand the heat. I keep mine on. We are hot, sweaty, and filthy. As we paddle, we laugh about a sentence in a letter I recently received from my doctor: "You are a well-appearing 60-year-old gentleman in no apparent distress." Our pants and shirts are splotched with brown river guck. I have mud on my hat too, and mud on my hands and face. Oh yes, well-appearing, and so far, in no apparent distress.

But we are acutely aware that distress can set in at any moment. These two logjams were our first, and they were daunting. What more could be in store for us?

Approaching jam number 3, I notice that already a standard dialogue is developing: "We might be able to move those logs . . . Glad I kept these hip boots on . . . Maybe we could get over there . . . That was a real logjam."

2:12 PM

We pass under Ann Arbor Trail. I hear another cardinal. And smell sewage. Lots of barn swallows are nesting under the bridge. They buzz between our heads and the bottom of the span. We log the sight of our first abandoned shopping cart under the Ann Arbor Trail bridge. A car's engine block lies in the muck. We see sunken picnic tables. That must mean we are near Parkland Park in Dearborn Heights.

I remember park officials assuring me the restrooms would be open at the park. Last week I checked, and one of the two restrooms was open. Pat stays with the canoe this time. I climb up the bank and stride up a wooded hill to the restroom I'd previously looked into. It's locked. I go back to the canoe. Pat climbs the bank and checks the other restroom. It's locked too.

Instead of giving stars, our restroom rating system awards between one and five paddles, depending on the quality of the bathroom facilities. Parkland Park gets a zero score. No paddles.

Nancy Yipe rings my cell phone. I reach down, pop open the waterproof plastic box, and answer the call. She tried to get into the park, she says. It was locked. Locked? On a bright Tuesday morning? That's odd. Another oddity is that when I had talked to the city folk, they had assured me the river was not accessible from

A mud-covered engine block is among the many pieces of automotive trash we saw on the Rouge River. These auto parts now rest in an area of Dearborn Heights where the river is surrounded by woods that seem impenetrable.

We pass the first of many abandoned shopping carts under the Ann Arbor Trail bridge in Dearborn Heights. This one rests on its side in nearly opaque brown water.

the park. But, in fact, the river is close to one of the park's lanes, and the park could be a fine canoe launch site. So, I'd put Parkland Park down as a reliable put-in, take-out place for us. Not so though, if the park was not going to be open, let alone have locked restrooms.

From now on, I was going to be concerned about the day ahead of us and how far we'd get. The list of viable launch and take-out places is pretty short. I review it as we paddle. I thought the bridge at Outer Drive could work. I also had permission from the man-

ager of Grand Lawn Cemetery to put a canoe in and out, and for that matter, to use their fine restrooms. I'd found a possible access site just below Five Mile Road in Eliza Howell Park, though it was some distance from a park road. Farther north, I'd found a site behind the Super Kmart, just south of Eight Mile. The manager of Beech Woods Golf Course in Southfield offered to let us use the fourth hole as a take-out and put-in site; he even offered to haul our canoe with a city truck. The bridge at Nine Mile also looked doable. I thought in an emergency, we could pull out at Ten Mile, west of the Meriwether's Restaurant on Telegraph Road.

None of these sites were ideal though. The Rouge has steep banks in most places. It's not uncommon to find vertical cliffs of soaking wet soil that are five to twelve feet high, with dense woods right up to the bank's edge. Sometimes, the banks are even higher. In an emergency—say if we simply couldn't make it through a logjam—we'd have to hike out to a main road and call for help. Getting the canoe out might be hard or even impossible. It is this knowledge of the difficulty of the Rouge—the veritable wilderness nature of this enterprise—that makes us lock out of our brains any thought of turning back. Meanwhile, each day and all day, I study my mud-besmirched maps, trying to figure out a reasonable place to stop for the day.

On day two, I am hoping we'll make it to Plymouth Road or even Outer Drive by evening. In my dreams, I have us getting as far as Grand Lawn Cemetery at Grand River and Telegraph. But as we become hotter and more tired, having encountered far more logjams than we ever anticipated, those possibilities start to seem unlikely. Toward the end of the day, I'll be on the phone with Nancy Yipe, or she'll be calling me, reporting on possible landing places.

Logjam number 4 looms ahead of us. It looks big. It is one logjam followed by a second and a third.

3:00 PM

A brown bird with an iridescent blue head pecks at the ground. A grackle. A log spans the river.

"I'm going to risk it—get out on the log," Pat says.

"Be careful, Pat," I caution her. "Can we maneuver the canoe where the tree's lower?"

"Now I'm getting the tail end of it. What I'm going to do is keep pulling. You just stay . . ."

"Just force the canoe over this. I'll get out."

"Okay."

Probing, climbing, pushing, and paddling, together we figure out a way to get the canoe over the jam. Suddenly, Pat pushes the bow through a mess of frothy logs, boards, and bottles. We are paddling clear.

"We're getting cocky," Pat laughs.

We go through another mess with little trouble.

"That's not a logjam," Pat says. "That's a log impediment."

Things can change suddenly. My procedure is to place my digital recorder in a waterproof plastic container before we don waders and life jackets and start our gymnastics atop the logs. One time, I forgot to turn

Saplings grow out of the vacant space where a windshield once was in this now junk car full of dirt embedded in the river bank. Dumping a car into the river has caused the bank to reform itself in and around the vehicle. Sediment from the river has filled the car's engine cavity and passenger compartment.

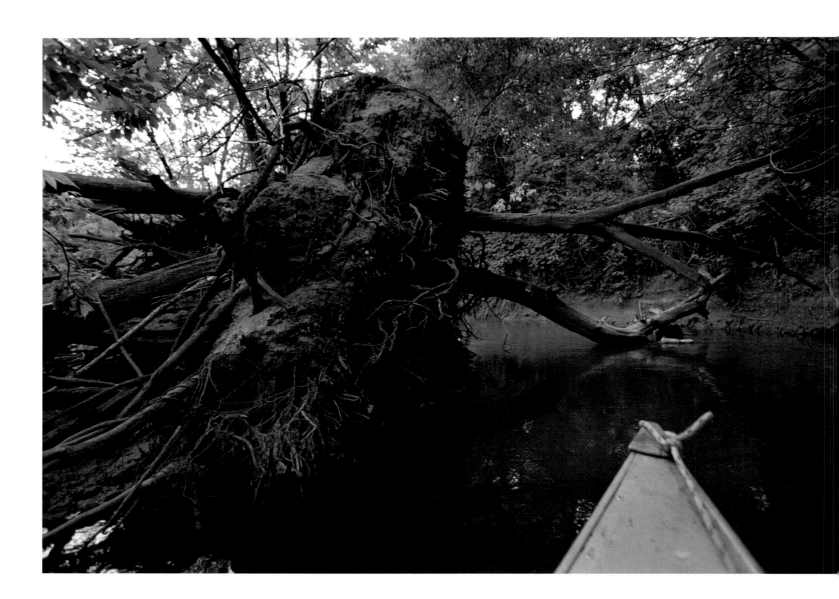

off the recorder. Apparently, the current was pushing us around, and the canoe hit something. I recorded bumping sounds.

"I don't think we want to be on top of that!" Pat says.

"Are you all right?"

"Don't be so brash!"

So brash? What happened is that Pat's hat had come off. Forgetting that she'd sensibly pinned its chinstrap to her shirt, I'd grabbed it—and nearly pulled her over.

"I'm sorry, Pat," I apologize. "I forgot your hat was attached to your anatomy."

After one logjam, I record sounds of panting and then the gurgling of rapid paddling.

"Wow! That was a logjam, am I right?"

"Yeah," Pat replies.

To the left, there is a small cut, like a stream inlet. It must be the Middle Rouge coming down from Novi, Northville, and Plymouth. It seems awfully small. Three big turtles slide off the bank into the water. A big heron flaps away. Ducks splash ahead of us. We then come upon a huge tree that blocks the entire width of the river, which I estimate is still sixty to seventy feet across. There is no passage for the canoe.

3:48 PM

We assess the situation. This is a logjam that is really three jams in succession. One big tree has caused two other trees to wedge against it upstream. The first tree towers over us.

"Bigger than a horse," Pat says.

We pass under with Pat on the bow and me putting my weight on the stern. Twice we do this: Pat steps carefully out of the canoe and onto the downed tree. She steadies the canoe as I crawl forward. I then step out on the side opposite her. Now, standing on the tree, facing each other, we lift the bow up onto the tree. We grab the gunwales and heave the canoe forward. When we can reach the thwarts, we grab them. We heave the canoe on across the tree, with the bow now slanting back down into the water on the upstream side. Pat steps back in and crawls down to the bow. Her weight in the bow steadies the canoe and lifts the stern, making it easier for me to push the remaining couple feet of hull off the log. From the log, I step back in and sit down.

While paddling toward another mess, Pat suddenly exclaims, "Ohhh, spider attack! Gross!" Often, the bow of the canoe encounters spider webs slung between branches or twigs. Pat jokes that I am aiming her at the webs.

The skeleton of a car, wheel, and outlines of a frame and transmission face us from the slick brown bank.

4:08 PM

We pass an ancient wrecked car lying on the east bank just south of a dead shopping cart. Pat changes film.

A large tree with its enormous root-ball still intact rests with other fallen trees across the Rouge River.

There's mud all over this car, but it looks like it once was maroon. What make of car? Can't tell.

4:21 PM

Logjam. A big tree spans the fifty-foot width of the river. These logjams make for hard work while canoeing. Same old deal. Pat and I get out, step onto a log on either side of the canoe, pull the canoe over, and dump it back in on the upstream side. A goose buzzes us. We see another car in the river.

4:35 PM

South of Warren Avenue we come to the ruins of a concrete dam. It makes a rapids. We put on our hip boots and life jackets and pull the canoe over the dam. North of Warren, we see a rock embankment and what looks like a walkway. From shore, a man shouts to us.

"I haven't seen a canoe on the Rouge in years!"

We see another car in the river, this one filled with silt, with saplings growing out of the glassless space where the windshield was.

4:57 PM

We are between Sawyer and Tireman Streets. Here we see a faded yellow car with a door hanging open. Stuck on its side in the mud is an old wringer washing machine. We then come upon three big combined sewer outlets in River Rouge Park south of Joy Road. A nasty smell fills the air. I am not thinking about that guy who fell in the Rouge, gulped water, and died of rat fever twenty years ago.

Logjam. We get out, jump up, jerk the bow line, and get through, only to face—wow! This next one is the mother of all logjams. Many, many logs are all jammed together. From the bow seat, Pat looks for a low point, a notch, or any kind of weak spot in the jam through which we can force the canoe. It looms high over our heads. Logs and construction debris—two-by-fours, two-by-eights, four-by-fours—are tangled in a real mess.

As we finish our fight with this jam, we have our first real scare.

"We almost tipped over," Pat says.

"We didn't tip over, so it doesn't count," I quickly reply.

But in fact we nearly got in real trouble on this one. We had struggled over and through many, many logs in a long, seemingly impenetrable jam. It was slow going. We had to test each log to determine whether it was firm or a floater, ready to slide away and dump us into the frothy mess. It happened when the ordeal was almost over. Pat had cleared the bow under a low tree that slanted across the river. We were nearly free. But the current pushed the canoe backward, and suddenly it was backing sideways under the horizontal tree we thought we had cleared. The tree and I could not occupy the same space. I had no place to go except overboard. As I leaned more and more to the right, I was

tipping the canoe.

"Don't lean!" Pat yelled.

The canoe came close to shipping water. For a second, it seemed, we were out of control, the canoe pushing sideways under the tree. It flashed through my mind that this could be very bad. Pat thought we were going to tip and grabbed the tree. The water was well over our heads. The river finds its way through these snarls, and it does so swiftly, by digging narrow, deep tunnels through the river bottom. As the canoe tipped further, I imagined what it would be like if we fell in. We'd be sucked through the perennial upstream mess of floating debris—tires, fire extinguishers, pop bottles, dead animals, and countless pieces of lumber and logs. We'd be pulled through that unpleasantness and into the jam itself, possibly towed underwater in our hip boots and life jackets. We could be snagged under there and drowned. The canoe and equipment would be a mess, but the crew was what mattered. This trip was not going to end that way. We both grabbed that tree trunk and pushed. The canoe swung free. We were clear.

At the next memorable logjam, we drag the canoe over many, many logs. Gradually, we work it to a spot where Pat takes a picture of the canoe suspended on dry logs several feet above the water.

5:58 PM

Pat eats a spider web full of cottonwood seeds. We deal with more logjams.

6:48 PM

Under the Tireman bridge, we pull the canoe past a sunken air conditioner. Nancy Yipe is there waiting for us with the Heavner canoe van and trailer. We have been over ten logjams and a ruined dam. And now, at the very end of our day's journey, it pours down rain. What luck that it waited until the end of the day, just as we pulled out the canoe.

At the Dairy Queen, the counterman watches this man and woman with dirty khaki pants and hats, muddy faces, and a rank odor as they order, again, a banana split and Heath Bar Blizzard. We had paddled, pushed, pulled, shoved, and towed the canoe 4.6 miles.

TAKE-OUT AT TIREMAN
9 HOURS PADDLED, 4.6 MILES
10 LOGJAMS

DAY THREE WATER BIRDS

7:38 AM

I'm driving along Hines Drive heading to Fair Lane to meet Pat and Nancy. We're hoping to get on the water before nine o'clock. The sky is gray. Thunderstorms have been predicted, with the high to hit 91. Our plan is to leave our cars at Fair Lane. We will ride with Nancy in the Heavner livery van, pulling the canoe trailer to Tireman in River Rouge Park. We'll put the canoe in right where we pulled it out yesterday, under the Tireman bridge.

9:06 AM

Pat and I drag the canoe down the same muddy bank we pulled it up yesterday in a driving rain. It is really easy to slide it down. According to the National Weather Service, the rainfall overnight was almost nil

in metro Detroit. We know better. We were soaked in a downpour as we dragged the canoe out, and now we notice the river is running several inches higher than when we left it.

Trees alongside the banks confirm last night's rain. Water marks on their trunks extend up not a few inches but three feet above the present river surface. Even having been warned about the river's flashiness, it is something to see visual evidence of it firsthand. We can only imagine what the force of last night's current would have done to our little canoe had we stayed on the river.

I stand on the bank and remember some of my pre-trip research. The U.S. Geological Survey began recording the volume of this river's streamflow in 1930. By 2003, the June streamflow had increased sixfold. The random, periodic surges that come with every rain make life hard on the fish and birds in this river. The floods wash away their nests and protective habitat. Birds that nest near the ground lose their young.

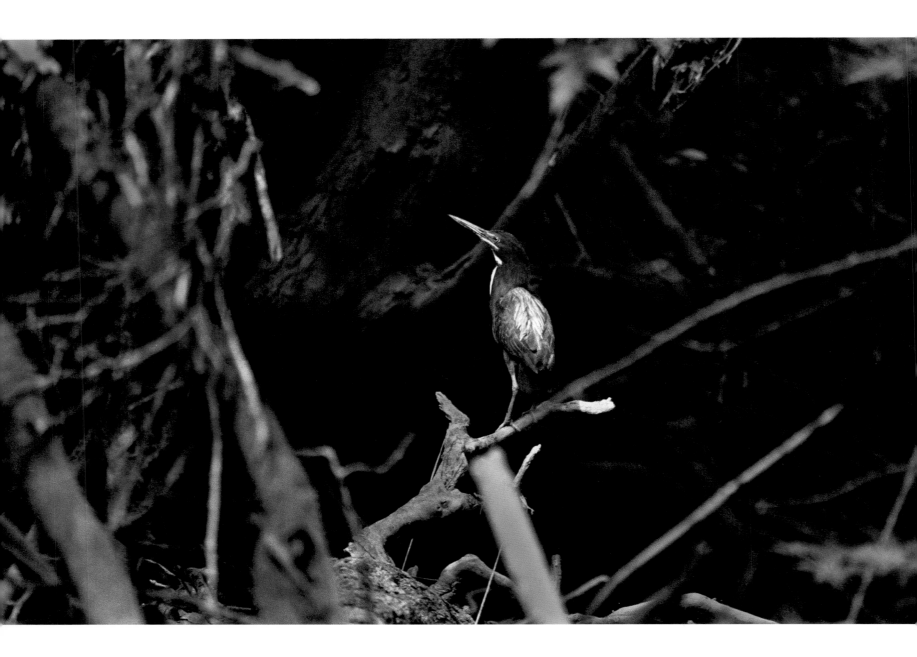

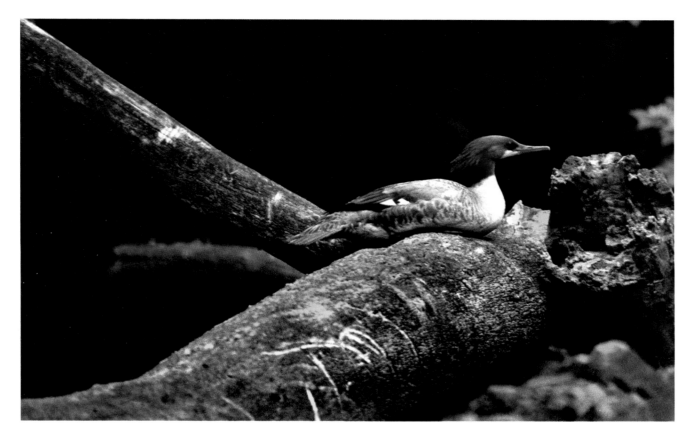

We paddle around a bend and spot a bird with iridescent green plumage poking around in a pile of logs. The presence of two humans in a canoe didn't seem to disturb this bird. It is a green heron. We saw many great blue herons but only this one green heron.

We spotted this adult female common merganser resting on a fallen tree beside the river and learned later that it was the first time this species of bird had been seen in the summer in Wayne County. Later, our sighting was recorded by the Rouge River Bird Observatory at the University of Michigan–Dearborn.

9:17 AM

We are on the river again. Mosquitoes bug us for the first time but not for long. Once we're on the water, we're left alone.

Tireman bridge is still in view behind us. Pat takes a panoramic shot of the glassy river surface. The river mirrors sycamores and maples overhanging its banks. A small, spindly-legged bird with a greenish-blue, iri- descent back and long beak poses for Pat. It is a green heron. Nearby, something duck-like with a reddish-brown head, and feathers splayed out at the back of its head, stands on a log. It has a white neck and tan or light gray body. Both birds act unconcerned, giving Pat plenty of time for shots. This second bird, we believe, is a common merganser.

(Sure enough. After the trip, we e-mailed a picture

of the bird to Julie Craves, director of the Rouge River Bird Observatory at the University of Michigan in Dearborn. Julie told us that ours was the first recorded summer sighting in Wayne County of an adult female common merganser. What we had seen was something special.)

9:45 AM

We hear cars and see a bridge. This must be Joy Road. As we paddle under the bridge, water from the road splashes onto Pat. The canoe's bottom scrapes. We push against the shallow riverbed with our paddles. We are through, suddenly.

We greet another logjam. It contains the usual wood debris, an old tire, plastic bottles, and foam. We clear it and by 10:12 AM have passed over another jam. Ahead, a stream flows in from the northwest. My map shows it to be Ashcroft Sherwood Drain.

Many people told us we were nuts to travel upstream on the Rouge. In addition to battling the hard current, we'd be foolish to do so because we'd become confused by the many tributaries that flow into the main stem of the Rouge. We'd likely turn up the wrong branch. My response was that except for Evans Ditch, the main tributaries come in from the left, or west. All we would have to do is keep bearing right and we'd be okay. Now I see that I could have added that we'd just follow the strongest flow. The tributaries are not very impressive compared to the size of the Main Branch.

11:04 AM

We listen to the cooing of a mourning dove and spot another common merganser, so distinctive with its rusty head and punk-like mane of longer feathers above its nape.

11:12 AM

The river is like a mirror. It's so quiet. Trees overhang both banks. The canopy of leaves and branches reflected on water is beautiful, even if the water is thick and brown. We've already battled several logjams and have decided to keep our hip boots on. Still in River Rouge Park, we see plywood shanties on the west bank. They look like duck or deer blinds.

Detroit's River Rouge Park is the city's largest park with 1,181 acres, including twenty-six thousand feet of frontage on the Rouge River. It has two hundred picnic tables, though they're deliberately placed far from the polluted water. There are twenty-one baseball diamonds, eight miles of bike trails, an eighteen-hole golf course, a nature study area, and a soccer field, but there are no public restrooms.

The park is an area of concern for us because the wooded river area is not policed, and we know there is much criminal activity in the surrounding Brightmoor neighborhood. Police have told me of a tent town for homeless people on the Middle Rouge in a western suburb, and I wonder if those shanties were built by indigent people in Detroit. Also, we know there are feral

dogs living in the city parks. We are on guard and a bit nervous as we paddle through this area.

11:29 AM

This logjam is nasty. Large uprooted trees extend over the river at all different angles. It is a very impressive mess.

"We can't go anywhere that way," I say, as we peer at this overwhelming tangle of trees and limbs. We continue to study our obstacle. "I think we might be able to pull it over that stuff."

Wow. We had to admire what nature had made, even though it meant much work for us. *Boom. Splash.* The canoe bangs against logs, and then we drop it back into the river. Beyond there are even more uprooted trees.

"The mother of all logjams," we declare.

11:56 AM

We are still dealing with this logjam. We've been scouting it for quite a while. Two gigantic trees are down across the river at diverging angles, and many small and large trees have been washed down and are caught against them. We get out, stand on the first tree, and pull the canoe over its trunk. We count—one, two, three, four, five, six, seven, eight, nine, ten logs ahead of us, each somewhat—or a lot—higher than the previous one. We turn the jam into an escalator, pushing, bumping, tugging, climbing. We are out of the canoe, testing logs for firmness, pulling the boat along and upward.

"Any other mothers we talked about before were not mothers—they were daughters of logjams," I remark.

Bam bam bam bam bam bam.

"Gunfire!"

Somewhere south of Plymouth Road we had noticed a blue and white building with a bedraggled U.S. flag. A cardinal sang. Then *rat-a-tat-tat-tat-tat-tat-tat-tat.* Machine guns? I'd been warned that we would pass the Detroit Police Department's firing range. I guess we found it. We listen to the sharp sounds and hope they don't find us.

"I feel like we're being chased," I say.

"Maybe they're celebrating our departure," Pat replies.

12:31 PM

The gunfire continues, but we are now otherwise occupied and stop worrying about it. We have just pushed through another god-awful jam of logs. We are devising names for the parts of logjams. We start low, at the floor. The highest point is the roof. With her unerring eye for the low points and niches that make seemingly impenetrable jams workable, Pat has spotted the slot through which we push the canoe. The hull squeaks and groans. How long will these rivets hold, I wonder. I think of old *Suicide,* the wooden canoe I paddled on the Flat River as a kid. I would not abuse a wooden canoe this way. I imagine for a moment the pioneers beating a

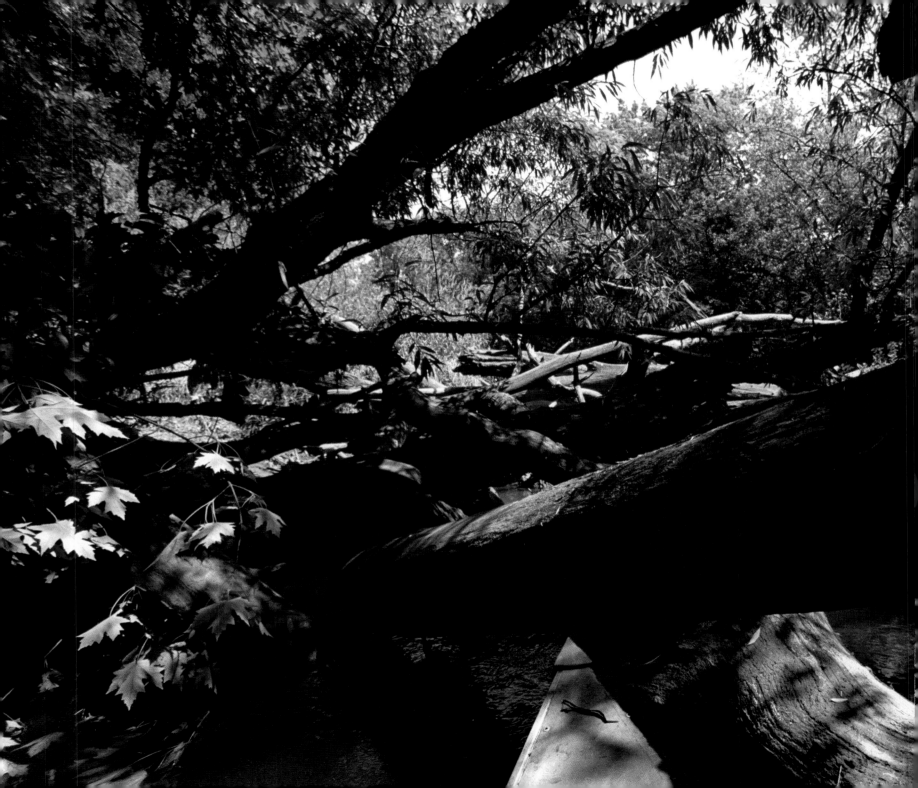

bark canoe like this. No way. They'd portage.

We push the canoe high onto the roof of the jam and work it forward while climbing over a series of slanting trees. We walk slowly, carefully, in our heavy rubber hip boots. Then it happens. Pat slips, tumbling feet first toward a mass of wooden debris bobbing on the six-foot-deep rushing river. I grab her left shoulder and right arm and hold on. Her bottom is barely lodged on a log. With a series of short butt hops, she works herself safely back onto the log.

Boom boom boom boom boom.

"Beck the engineer, the woman with the angle, figured out a way through what I don't think anyone else would have noticed."

"And Joel saved my life."

"Yeah, we took a couple of spills on that one, didn't we?"

"But you know," she says, "we don't have any water over our hip boots. Hold it—I'm going to take mine off. I'm sweating."

"Let's find some shade and have lunch."

12:43 PM

Another logjam, and this one has to be the mother of all logjams, gargantuan as other logjams may have seemed.

12:49 PM

The cops keep on shooting. Where are their bullets going, we wonder. Meanwhile, we find a decent spot on

Downed trees tower over our heads as we come to a large logjam in Detroit's River Rouge Park. It seems as if we are blocked in every direction we look.

the river bank to ground our boat and eat our peanut butter and jelly sandwiches.

A half mile south of Plymouth Road, we put our waders back on. A huge maple tree on one side and another tree from the opposite bank are blocking the river. Up in the bow, Pat pushes her paddle against the logs. She is out of the canoe, mounting a downed log. As we push into some brush, she pulls out a pair of garden pruning shears and snips away the small branches. Often, we encounter low-hanging branches with leaves and twigs that hamper us, poking at hats, eyes, faces. Sometimes the branches project at us from nearby banks, or they may hang suspended from trees that have fallen to straddle the banks. They are a nuisance. Slowly, with her rubber-gloved hands, Pat then pulls a log out of place and gradually dismantles the upstream pieces of logjam, making a path for the canoe.

2:23 PM

We come through jams number 6 and 7. Logjam number 8 for the day is a big shagbark hickory tree. We get out on the log and from either side pull the canoe up and over.

"The logjams we're having today are much more intense than the ones we had yesterday," Pat observes.

Some of these logjams are old enough that they have grass and weeds growing on them.

2:47 PM

We are halfway across a logjam that we guess is seventy feet long from downstream to upstream ends. Logs are piled high along with debris—a tire and bottles. We pull the canoe about thirty feet through it, slowly realizing just how many trees and logs are in this one. Then I slip and fall. My butt catches on a log, but my right leg shoots into the river. Water surges into my right hip boot. While my leg is in the water, the extra weight isn't really apparent, but when I try to haul the boot full of Rouge River back onto the log, the extra pounds are alarming and make me clumsy when I move.

I think about my last-minute purchase of this footgear. My feet are getting sore rubbing against the hard rubber boots. However, without them, I don't know what we'd have done. The heavy rubber treads give us traction when we walk on the logs and trees. They protect us when we get out and slog through the muck, towing the canoe in shallow water or even lifting it. And for climbing banks, they are absolutely essential. Tennis shoes or any other kind of footgear, like the rubber-toed boat sandals I wore on day one, wouldn't have cut it.

3:02 PM

"It took us half an hour," Pat says.

That jam was a horrible mess. I undo the plastic garter that attaches my right hip boot to my pants belt. I remove the boot and pour brown river water back into the Rouge. We are both very, very tired.

3:07 PM

"Put your waders on," Pat says.

Coming around a bend, we see a huge tree lying

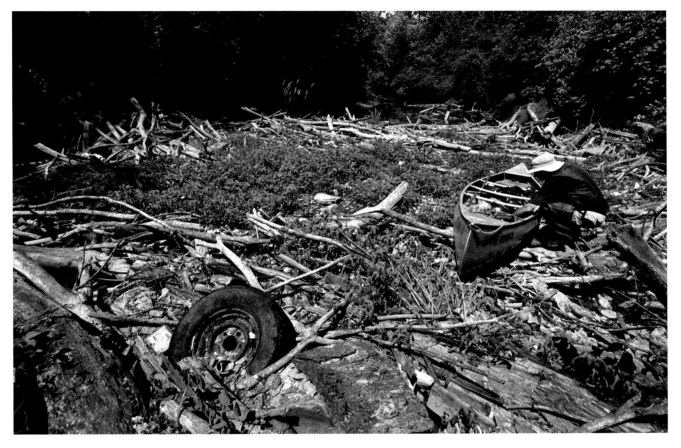

The author squats on a secure log and checks gear in the canoe midway through traversing a large logjam. This logjam consisted mostly of floating logs and debris held in place by fallen tree trunks. We never felt very safe while standing or walking on logjams. What might seem quite solid one moment could twist or turn in the next as we put our weight on it. Often logs were supported partly by other logs or by their own buoyancy, so that applying any weight could ruin the perceived stability. Sometimes we stepped on logs just at the surface of the water; other times our crossing was several feet above the water, as we climbed over piled-high branches, logs, and debris. Some logjams seemed to be alive, heaving in the current and in response to our movements. To check for stability, we would test with a foot to see whether a log would move under our weight. Sometimes a log would shift or slide out from under our feet. Then the trick was to keep our balance. Sometimes we could, and other times a boot-clad foot would plunge into the water.

across the river with a bunch of stumps piled up both above and below it. We hear cars too. Somewhere up ahead is a bridge. We like bridges. They tell us we're making progress.

"There's an opening on the left we can get through," Pat points out.

We clear that awful-looking mess without stepping out of the canoe. It therefore doesn't count as a log-jam.

3:15 PM
We arrive at the bridge where lots of traffic fills the air

with roaring. It's Plymouth Road. These are the logjams then—or ones like them—that reporter Bob Pisor had to deal with. This was the place where he wrote that he was "defeated" in 1979 when he tried to canoe solo up the Rouge.

3:17 PM
Waders on. Life jackets on. Within earshot of Plymouth Road, we approach a new logjam.

3:38 PM
Into my recorder I report on our latest encounter: a major logjam. Pat sees a wood duck fly over. I miss it. It just looked black on top with a white stripe around the beak, she says. We negotiate a jam that has us jimmying the canoe under logs and over flotsam. It takes

awhile, and both of us get out. I pull with a rope from upstream, and Pat pushes the stern from downstream.

4:09 PM
We finally paddle under what the map tells us must be the Plymouth Road bridge. The traffic is loud, and the river reeks of sewage. Swallows buzz us. A big window fan lies on its side, embedded in the bank.

"We had a long stretch without a jam," Pat says, referring to the last couple hundred yards of rubbish- and log-free river that gave us a few minutes of relief and kindled hope that the jams would end. No such luck. We are trying to speed up. We've come only two miles, as the crow flies, since putting in at Tireman seven hours ago. We had hoped to get close to Oakland County today, but we hadn't counted on the thirteen

We paddled into the golf course at Detroit's River Rouge Park and found that we had blundered into an "artillery range." Golf balls were embedded deep in the banks of the river. Paddling at eye level to the green, we were afraid we might become unintended targets.

Still paddling through the golf course, we saw this common snapping turtle, which we guessed to be twelve inches across, sunning itself on the muddy bank. It was the first and only turtle we saw that didn't dive into the water as soon as we appeared.

logjams, daughters of logjams, mothers of logjams, and even mothers-in-law of logjams that we'd gone through so far today.

"What's interesting is that what we thought was incredible yesterday is a piece of cake today," Pat says.

"Golf balls," Pat comments, as she points to the river bank. Stuck in the mud on both sides of the river are dozens and dozens of golf balls. We'd entered the golf course in River Rouge Park. We also pass a gauging station—a big yardstick used to measure river depth. My map shows it's one-eighth mile north of Plymouth Road. Here and there we see walkways with bridges over the river for golfers.

On the east bank, with its crocodilian tail lying close to the water, a snapping turtle basks in the sun. Its shell is about twelve inches in diameter. Pat quietly lifts a camera from a waterproof bag. I backpaddle, holding our position. Pat makes a curve with her hand, showing me where she wants the canoe to head. I slowly point the bow around, drawing the boat nearer, and nearer yet. We are having great luck. Normally, turtles skedaddle at the sound of us. This one is staying put.

"Is he dead?" whispers Pat.

The turtle's beak is out of its shell. It seems motionless, but as we come closer, its head moves, pushed outward by a bulbous neck. This happens very slowly, and Pat meanwhile shoots several frames. Closer, closer.

"He's not dead," I whisper.

Closer. Pat shoots again. Again. Closer. The big snapper swings around and launches into the river. It's gone in a swirl of brown water.

4:30 PM

We hear something moving on the west river bank. It is a man in two-tone shoes holding a long metal stick. We see that it is a tubular ball retriever. He is pointing it down the bank, toward an embedded golf ball.

"Are you playing golf or finding golf balls?" Pat asks him.

"Still playing golf," the man replies, surprised. His name is Dan Wainaina.

"What are you doing? Working?" he asks us.

"We're with the *Detroit Free Press*," Pat tells him.

"We started out Monday at Zug Island, and we're trying to find out how far up the river we can go in a canoe," I add.

"That's pretty good," Dan says. "How far you gonna go?"

"As far as we can get," I say. "This is the third day. We've got till Friday."

"Wonderful!" he says.

"How many canoes have you seen on this river?" I ask him.

"I've never seen a single one. You surprised me. I looked back and didn't know what the hell that was."

I reach over to the bank, pluck a golf ball from the mud, and toss it to him. I notice a huge crayfish on the bank as we paddle away. Dead.

4:40 PM

It dawns on us that we could be targets. There are many, many golf balls stuck in the mud on both sides of the river.

"Look how far they're stuck in," Pat says. "They hit hard."

Logjam number 14 is an easy one. We force the canoe through.

About this time, we realize that we are taking on water in the canoe. Dark, ugly water. I wonder if we've popped a rivet. But then I watch myself and see water run in gleaming streams off my paddle every time I shift sides. The water falls into the boat and onto our plastic-covered lunch coolers, water coolers, life jackets, everything. It has pooled in the bottom, a black yucky mess. Pat has an idea. We use Ziploc bags as bailers. But we quickly find that they're not so great for this purpose.

"Hey," she says, "let's cut the bottom out of a water bottle."

I pull out my Swiss Army knife and carve the bottoms out of two plastic bottles. We bail. The water is not only filthy, but it adds to the canoe's weight when we haul it over logjams. We're glad to lighten our load.

Again, we hear gunfire.

5:06 PM
We pass a huge willow tree and a series of logjams. We squeeze through the first. After that, we are into layered logjams. We paddle past a television set in the mud. We've done fifteen logjams today, and there is another one ahead. I am concerned about where we're going to take out this boat.

5:32 PM
Logjam number 18 is a doozy. It is complicated by crisscrossing logs and branches. Pat pushes a huge floating log upstream of the jam. It's very heavy and moves slowly as she aims it into the current. An underwater branch catches it and acts like a spring, pushing it back. Finally, it floats free. So does a soccer ball. Ahead is a small opening. We push and pull together, with lots of knocking and scraping. Pat pushes with a paddle, and I push on logs, and together we move through jam 18.

"We're bad," Pat pronounces.

Logjam number 20 is very complicated. The water is deep and moving fast. After conquering it, we reflect on how we had an incident with the canoe tipping and being out of control for a couple seconds on jam 19. Into the recorder, I say, "We both realize it could have been a nasty end to our excursion."

"It wouldn't have been the end," Pat counters.

"It's also worth noting that we're both very hot, very sweaty, very grimy, and very dirty."

"I'm glistening," Pat retorts. "Men sweat, women glisten."

A duck swims alongside and pokes her head underwater. Two golfers on a motorized cart spot us.

"Hello," we shout. They wave and drive off.

"The golfers looked very spiffy," Pat says.

We are filthy. Our canoe has muck in the bottom, and branches, leaves, and twigs cover our gear.

We hear thunder and notice that the sky is darken-

Pieces of junk like this television set cause sediment to build up around them and snag floating branches, creating islands of silt and debris.

ing. The river here is about forty feet wide. The banks are ten-foot vertical walls.

We hear the low growl of engines, radial engines. Through an opening in the trees I see a big four-engine airplane with a tall tail. It sounds and looks like the World War II B-17 from the Yankee Air Force.

6:30 PM

Another rumble of thunder. We need to get off this river. I am picturing a huge rainstorm and a wall of water flooding down the Rouge with us bobbing around among jams and debris with no way out. I call Al Heavner and tell him I am sure we can get out at Outer Drive. I had scouted the Outer Drive bridge a couple weeks ago. Not perfect, with its steep banks, but workable.

Pat and I agree that if the logs were cleared out, this stretch of the river would be a great place to canoe. There is plenty of wildlife. But the jams are ugly. They capture huge messes that stretch upstream for many yards. Scum and debris collect in every one.

Once today, we smelled something really foul as we crossed a jam. We let the canoe drift back toward the scummy upstream edge of the jam, and that's where we saw it: ribs whitened where they poked into the air, the fur still on the dog below the waterline. A leather collar still encircled the skeletal neck.

7:05 PM

Under the CSX railroad trestle, we come across another logjam. The water is shallow but flowing fast. In the dim light under the bridge, I see we are heading into a rapids created by lots of junk. With Pat still in the bow seat, I get out in my waders and haul the lighter canoe. The water is really running fast. Free of the mess, we paddle again. In the middle of the river, we pass a partly submerged car. It is car wreck number six that we've seen. Months after our trip, I learn from a Detroit cop that people like to roll cars onto the railroad trestle so they can watch locomotives knock them into the river.

More thunder. I am on the phone with Al Heavner again. We are getting really worried because it is starting to rain. Ahead, we see concrete. A bridge! The brown surface of the Rouge is pocked with raindrops. We paddle determinedly upstream. I get out and Pat holds the canoe to the bank. In my heavy rubber hip boots I galumph through the muck and up the bank, pushing my way through brush and tree branches. I round the corner of the bridge abutment and find myself on a street. At the corner, I see a street sign. Outer Drive! I put that news on Al Heavner's voice mail as I scramble back down to the canoe. Suddenly, over the bridge rail a head appears. It's Al Heavner.

8:20 PM

Today we made it through twenty-two logjams and traversed 4.2 miles of Rouge River. We were lucky. It didn't rain really hard until we got back to the Fair Lane parking lot. We both got soaked but were grateful it didn't happen while we were on the river.

In the Dairy Queen, we try to clean up a little in the restrooms. Later, standing in line to order, a girl maybe

nine years old stares at us. We have Rouge River muck on our shirts, pants, and hats. We no doubt smell of Rouge River sewage.

"We don't normally look like this," Pat sweetly assures her. "We just got done canoeing on the Rouge River."

The girl backed away.

Over her banana split, Pat shows me a deep red mark on the inside of her right wrist. She is not sure how it happened, but it doesn't hurt, she says. I notice that I have many little cuts on my arms, legs, and feet. Except for when I walk in my hip boots, they also don't bother me.

While paddling, I have been wearing sailing gloves that partly cover my hands, leaving my fingers free. For working in the logjams, I put on rubber gardening gloves. Somehow, though, my hands and arms were cut and scraped anyway. I was too busy to give them much thought until the episode when my boot filled with opaque brown water, and I realized I might as well have been swimming in the Rouge, the very thing we wanted above all to avoid. Once immersed, there was no quick way to take the cleanup advice that the county sanitarian gave us. A shower and soap would have to wait several hours.

Meanwhile, we sit a few more minutes in the Dairy Queen with the topo maps laid out on the table. Outer Drive is just one-eighth mile south of Interstate 96. Oakland County lies enticingly four miles straight north. But it is twice that far in river miles. Could we make it from Outer Drive to Eight Mile Road in one day? Probably not, but we agree that we will try.

"It would be great if we could canoe across one whole county," Pat says.

We are both exhausted and excited. Two more days on the river. With luck and hard work, we will make it to Oakland. We agree to meet at 7:00 AM Thursday to get in a full day of paddling.

TAKE-OUT AT OUTER DRIVE
11 HOURS PADDLED, 4.2 MILES
22 LOGJAMS

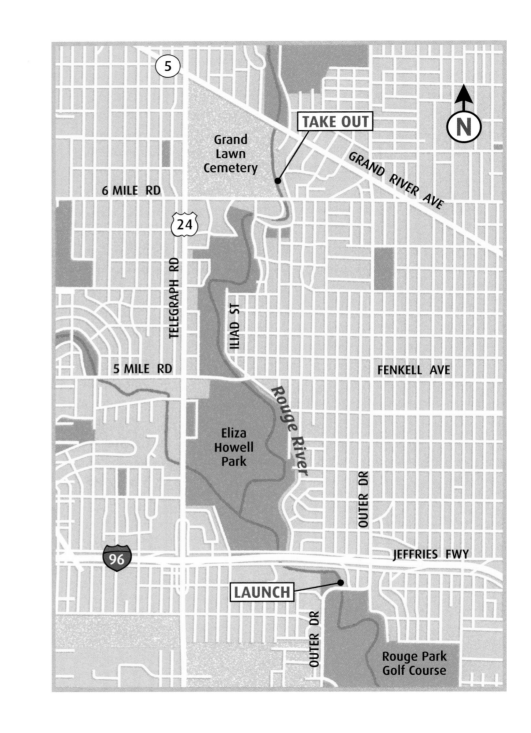

DAY FOUR HIP BOOTS AND LIFE JACKETS

THURSDAY, JUNE 9
90°F
LAUNCH AT OUTER DRIVE

7:00 AM

We meet at the Travelers Building parking lot in South-field. The *Free Press* Oakland County newsroom is in this building, but we don't go in. Nancy Yipe gives us a ride down Telegraph, and we are shoving the canoe back into the Rouge under the Outer Drive bridge at 8:00 AM.

We notice a change from yesterday. Last evening, the water was less than mid-calf in height. Today, it is knee deep and running faster because of last night's big rain. Pat notices something else. On the ground under the bridge where she had set her camera bag there is now an empty Marlboro carton, an empty liquor bottle, and one shoe. We've hardly seen anyone on this river for three days, but someone had been here last night.

We note water marks on trees eighteen inches above the present water level. Wow. Once again, we are glad we were not on the water right after that rain. Tree roots that would have been fully exposed on the banks yesterday are underwater today. We wonder whether this change will help us or cause problems.

Here is how things look to us at the beginning of our next-to-the-last day on the water: If we can make Grand Lawn Cemetery today, we will be set to enter Oakland County on Friday. Yesterday, we went 2.5 miles as the crow flies. From Delray Park, where we started, to Outer Drive is 17.7 miles. Can we do 3 straight-line miles today? So far, we'd battled thirty-two logjams. Mark Phillips counted fifty-two jams last summer, between Dearborn Heights and Civic Center Drive. That should mean we'd done the majority of logjams. Twenty to go—assuming things today are like they were during the summer of 2004.

8:09 AM

Twenty or more feet above the river, just north of Outer Drive, we see five pipes three feet in diameter that are more combined sewer overflow outlets. They have metal grates caked with colored papers—sanitary napkins. A concrete ramp leads slantwise from the mouths

A combined sewer overflow outlet just north of Outer Drive in Detroit. The Detroit sewer system was designed so that when a storm overburdens the combined sanitary and storm sewers, the excess—sewage mixed with rainwater—is pumped through sewer outflows like this directly into the Rouge River. The concrete Vs help to spread and slow the sewage water, so its potential for gouging the riverbed is reduced.

Traffic noise echoes under the Interstate 96 bridges in Detroit. Vegetation grows in a narrow shaft of sunlight between the two massive concrete overpasses.

of these outlets down to the river. Inverted V-shaped pieces of concrete on the ramp slow and distribute the surge of sewage water from the outlets.

It is very humid. The high today is predicted to be 90. We paddle closer to the outlet and notice that some of the paper is white. Toilet paper. A train honks. A dozen mallards swim ahead of us. We hear the traf-

fic on I-96, very close. We are paddling west, parallel to the freeway. The river curves north toward I-96. At the curve, we see four more three-foot pipes. We count twenty-two mallards swimming ahead of us, under this sewer outfall. A sign above the sewage ramp warns "DANGER—PUMP SPILLWAY—KEEP OFF."

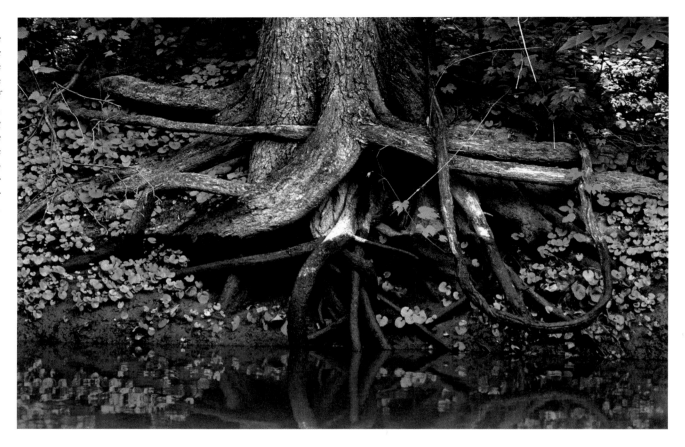

The exposed roots of a tree show evidence of the dramatic rise and drop in the river's water level from the previous night's rainstorm. Decades of construction of hard surfaces, such as roofs, roads, and parking lots, throughout the Rouge watershed means rainwater has much less chance of soaking into the earth. Instead, it rushes for storm drains and causes the river depth to rise and fall rapidly.

8:37 AM

The ducks swim ahead of us as we paddle under I-96. Swallows fly under the bridge. They make long beeping noises. Traffic thunders overhead, making an echoing din under the highway. I paddle the canoe just enough to hold it steady in the slight current. Pat changes lenses to photograph the ducks. North of I-96, the river bends west. So far, we've encountered no serious logjams and no abandoned cars. We enter Eliza Howell Park.

8:51 AM

We paddle a mile or so without seeing a single logjam.

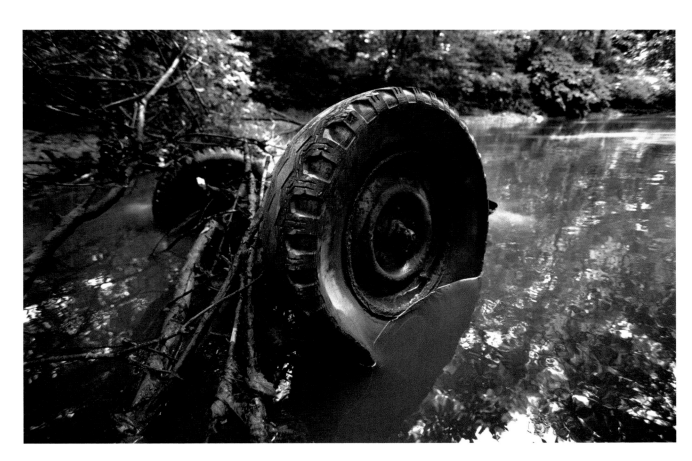

Tree limbs snag in an axle with its wheels and tires still intact.

11:09 AM

It's two hours and four logjams later. We've been working pretty hard, trying to get ourselves over and under various logs in Eliza Howell Park. The little honeymoon is over. We bail out the canoe with our makeshift water-bottle scoops that we made yesterday. We are taking a breather. The current here is swift. We measure the water marks on trees—three feet above the surface. That means the river has been receding toward the level we knew yesterday. What it also means is that it was good we got off the water when we did last night. The high water must have come on fast. We

find a two-foot-diameter drain with water still pouring out. It smells of sewage, although the odor might not have been from the drain. We head under some low branches.

"Spiders!" Pat yells.

We come upon another big sewage outfall. This one is a twelve-foot tunnel with the remains of a gate tied to hinges. The smell is awful. We paddle upstream and float down toward this sewage gate.

"If you could move slowly, that would be good—I'm unstable," Pat says. She puts a lens into its waterproof bag and takes another from its bag and puts it on the camera body.

"I'm getting nervous," I say. "I'm in a canoe with an

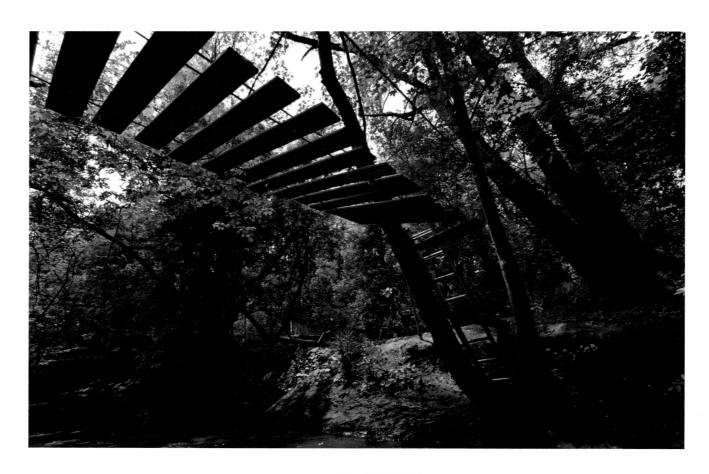

A handmade wooden suspension bridge spans the Rouge River north of Fenkell Avenue in Detroit.

unstable woman."

"We're not far away from that train trestle—did you hear that train whistle?"

I did. Sounds travel long distances over the river, or maybe we just hadn't paddled far from our put-in point. We see a big hawk amble over a log on the east bank. He flaps around the bend.

12:11 PM

We work through another jam, our fifth one today.

"We haven't seen the junk cars we saw in River Rouge Park," Pat says. The river narrows and, as if on cue, we see a junk car. That makes number seven.

12:46 PM

I am beginning to feel an ache in my back. Last night, driving home, it started to bother me. I thought the seat back was too straight, that I had become used to sitting on the canoe seat, back slanted forward.

Pat photographs the remains of a car: the universal joint, axle, leaf springs, two mismatched tires, and a gas tank.

"That tire on one side doesn't look so bad," Pat says. "Bet some gas got in the river."

12:54 PM

We see homes beside the east bank of the river. One house looks lived in—it has a satellite dish. Another house has plywood covering all the windows. It may have been burned.

12:57 PM

More houses. Stumps on the west side of the river show signs that they have been sawn. This is the first sign we've seen that anyone has tried to clean up the river.

"Could you paddle on the right side?" Pat asks me. "My right hand hurts. It doesn't hurt as much if I paddle on the left."

In a neighborhood just north of Detroit's Eliza Howell Park, the flow of the Rouge River current parts midstream around a blue car with a sunroof, one of sixteen cars spotted in a roughly four-mile stretch.

*A damselfly, almost certainly an ebony jewelwing (*Calopteryx maculata*), flexes its wings while at rest on a log.*

With the canoe parked atop a big logjam, we carefully walk over the debris, testing for a stable path over which we will later shove or pull the canoe to reach clear water upstream. On this jam, we wind up dragging the canoe directly over a cast-off sailboat.

Ahead, I spot a pair of big dogs walking through the woods. I'd heard we might encounter feral dogs. These two look healthy. We stay quiet, and they don't see us. They disappear in the woods.

1:15 PM

We see a concrete bridge ahead. It is Fenkell Avenue, same as Five Mile Road. A man walks across the bridge. He turns his head, looks at us, and keeps right on walking. Under the Fenkell bridge, we navigate to the right of a shopping cart. This area is a junkyard. We see lawn chairs, thirteen shopping carts, and parts of a car body and engine. Beyond the bridge, we find a huge tree and jumbles of wood blocking the river. This logjam is awesome. Its roof is, I guess, twelve feet over our heads. There is no passage. From the bridge, one of a trio of young men hollers, "What you catchin'?"

1:37 PM

We have on our hip boots and life jackets. No way can we work the canoe over or through this one. For the first time, we have to unload the canoe and do a true portage. We carry our gear forty feet upstream. Meanwhile, we still have gawkers on the Fenkell bridge. They make us nervous. This is a rough area. We drag the canoe up the east bank and around the jam.

Six logjams for the day, so far, and thirty-eight for the trip total. My back definitely aches. It's not bad, but I am getting a signal that it has been working hard. Pat

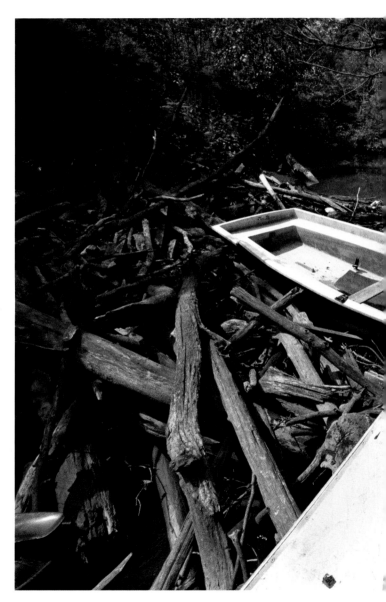

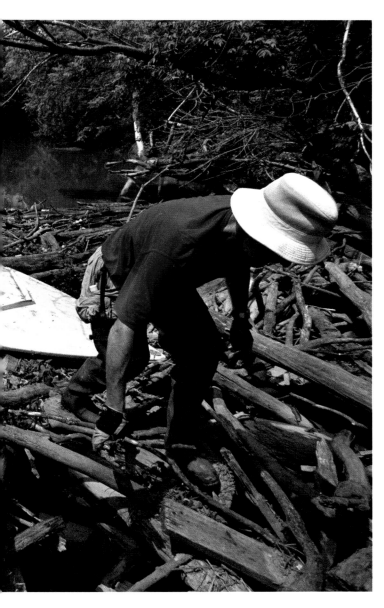

reminds me to paddle on the right. Her hand is bothering her. The last mess was the mother of all logjams, measured by the fact that we had to portage and could not force the boat through it.

The waders are wonderful tools. I've rhapsodized over them, and I'll say again that I don't know how we would have managed without their thick rubber soles to protect our feet on logs and trees. But I'd made a mistake. Pat is wearing socks because she normally wears running shoes. I normally wear rubber-toed sailing sandals without socks. I switch from my sandals to the boots whenever we need to go over a jam. Now, the hip boots are chafing my bare feet. My ankles, in particular, are hurting more and more.

2:06 PM

Ahead, a homebrew suspension bridge hangs over the river. It has plank treads for walking and two cables for handrails. On the west side of the river, we count four pup tents. Somebody has nailed a "No Trespassing" sign to a tree. Strung between trees are Christmas lights and party decorations. An extension cord leads across the river from a house on the east bank. I am amazed. I comment to Pat that between the overhanging cord and the bridge, we are looking at a few safety and city code violations.

"Shhh!" Pat says. "Somebody might hear."

Dogs bark as we pass. As we paddle beyond the bridge, we see two lengths of faded green garden hose

hanging from a tree and dangling above the river. Swings? This is our first indication that somebody might swim in the Rouge. Horrifying thought.

A few weeks after our trip, Pat and I were assigned to produce a story about this bridge and campground. I got out my trusty topographic map and the transcript of my log and guessed that the place was just north of Fenkell Avenue and east of Telegraph Road.

I went for a drive and found a street called Iliad that parallels the river. No sooner had I turned onto Iliad than I saw the house. It was a small yellow box with a pop-up tent in the backyard. Out back, a charcoal grill was smoking away, cooking what looked like chicken. A man lay on a lawn chair. I asked if I could talk to him.

Come on around, he said.

As soon as I entered the backyard, I saw it: the Mackinac bridge it's not.

But Kenneth Patterson proudly showed me the bridge he'd fashioned by hanging a pair of seventeen-thousand-pound-test cables between pairs of trees on both sides of the Rouge.

Sure enough, this was the ramshackle bridge Pat and I paddled under.

He attached wooden slats between the cables and hung an additional pair of cables that serve as wobbly hand rails. He didn't measure anything but guessed its span as about forty feet.

Patterson's friend, Anne Jones, doesn't like the neighborhood. Wild dogs chased her out of Eliza Howell Park.

Big, shepherd-type dogs, they had their hackles up and barked as they forced her into her car.

Worse, though, are the criminals. That very day, Jones said, a man tried to rob her. The day before, a man was shot fifteen times, execution style, Jones said. "It's the fourth murder here since the weekend."

Those bulletproof windows in the Wendy's around the corner? Good thing we didn't follow my original plan and park the canoe along the river and try, one at a time, to eat and get relief in that fast-food store.

We cruise our little canoe alongside this bizarre settlement. Party camp? A dog barks again. A second dog takes up the alarm. One is tied and the other is in a pen.

"Don't forget to paddle on the right," Pat says. I keep forgetting. Paddling on the left from the stern seat is an old habit.

2:29 PM

The roof of a sunken car juts up from the surface of the river. It is a blue car with a sunroof. Hanging from a tree branch over the middle of the river is what I first take to be a water balloon, albeit flesh-colored. Except for the nipple at the bottom. It sways in the breeze. Here and there along the banks, I notice other condoms. Pat is convinced people come to the river banks for their trysts and just drop the condoms when they're done.

"You wouldn't flush something like that down a toilet," she insists. In my opinion, they are coming from

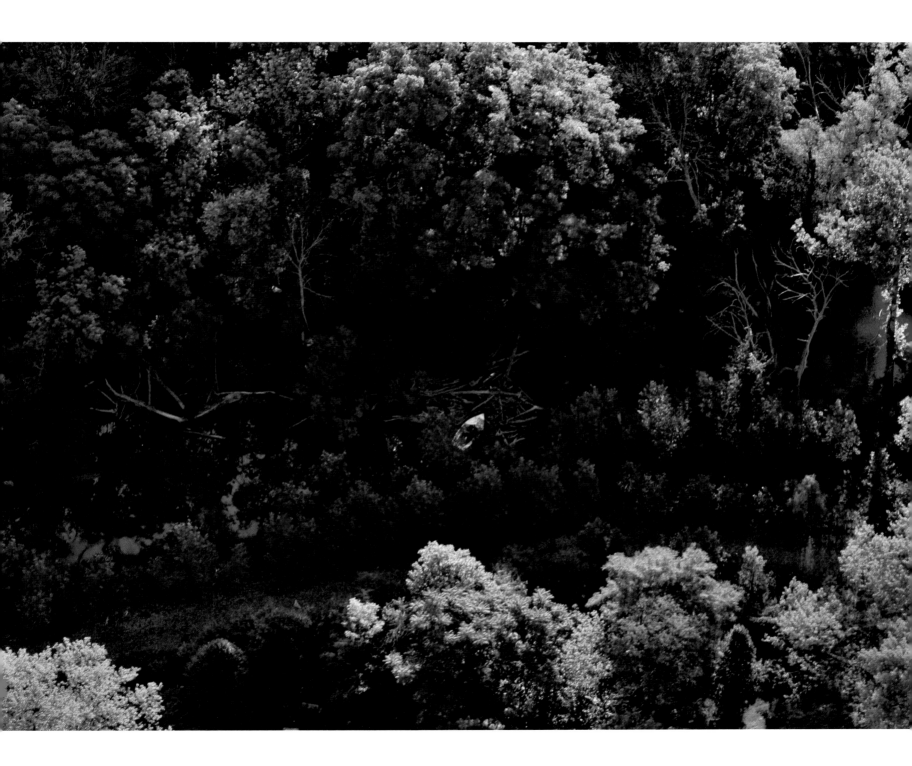

the combined sewer outlets. We paddle and dispute whether people trash rubbers in their toilets until 2:38 PM, when another logjam gives new meaning to "humongous." This one is unique. A fourteen-foot fiberglass sailboat, watercraft registration MC 1464 PW, is lodged atop the roof of the jumbled mess of trees and limbs. I figure the sailboat was dumped on the logjam by someone eager to dispose of it and too cheap to pay a landfill fee. Pat disagrees with me. Her theory is that the boat floated downstream and was driven high onto the roof by floodwaters. Neither of us know for sure.

I called the Michigan secretary of state's office and learned that the registration, which expired in 2000, for the sailboat perched on the logjam was in the name of Scott Tobias of Royal Oak. I called Tobias. Yes, he remembered the boat. He had paid three hundred dollars for it about ten years ago. It was a CL-14. Somebody stole the mast, he said, so he gave it to a friend of a friend, and after that he never knew what happened to it.

"It's sitting on top of a logjam in Detroit," I told him. "If you want to go get it, I can give you a rough idea of where it is."

"I don't need to find it," Tobias told me. "I think I'm done with it."

My rough idea of where that sailboat was sitting turned into a precise image on August 29, 2005, when Pat and I traced our canoe's course from a thousand feet above the Rouge in a helicopter. Nancy Andrews, head of the Free Press *photo department, was flying out of De-*

troit Metro Airport and happened to look down at the river. Why not send Pat aloft for a look at the Rouge from the air, Nancy thought. Me, I got to ride along. From navigating with mud-spattered topo maps, tracing river bends through the woods, and now and then hopping up to look at street signs, we suddenly were trying to follow the Rouge's meandering, often tree-cloaked course from the air.

Suddenly, Pat saw it: the sailboat. I made a note—half a mile or less north of Fenkell, or Five Mile. That happened to be just a few hundred yards north of where Kenneth Patterson had built his suspension bridge. I registered that, and gradually something else occurred to me. We'd wondered how people had managed to get cars down to the river. Pat assumed the sailboat floated down the river and snagged atop the logjam. I also learned from Mark Phillips that he didn't see the sailboat in the summer of 2004, when he canoed down the Rouge. So, it had to be a relative newcomer. How, I kept wondering, did that sailboat get on that logjam?

On our way to Kenneth Patterson's house, I noticed a gravel road leading north from Fenkell following the west bank of the Rouge. Backing onto the road are many businesses that front on Telegraph Road. Most of them are auto-related—collision and car repair shops. I had a hunch, and one hot day in early September 2005, I grabbed my lunch bag and drove my car down Telegraph to Fenkell. I headed up the gravel road and stopped after about a hundred yards. Upturned fragments of orange bricks littered the road. On either side were heaps of cut-

up brush, auto tires, whole sections from the interiors of autos, concrete rubble, and shingles. In fact, one pile of shingles had been dumped right on the road. Beside the road, someone had put out cardboard box covers filled with cat food. One top was labeled "woods cat." Another was labeled "woods dog." All around were empty tins of cat food.

I walked into the woods and down to the river. There, sure enough, was Kenneth Patterson's suspension bridge. He'd added a metal gate on the west side since Pat and I had visited a couple weeks earlier.

From here, I turned and walked north, following a path. Things got rough, and I wished I hadn't worn a brand new pair of slacks and my nice leather shoes. I kept walking, though, because I was sure the sailboat lay ahead of me. I broke through brush, got snagged on wild raspberry plants, hopped over trees, and ducked under others. First I recognized the blue car in the middle of the river. I remembered paddling to it and then maneuvering the canoe to Pat's commands as she shot photos of it.

Less than thirty yards upstream from the blue car was a big logjam. I peered around a tree trunk. There it was: Scott Tobias's sailboat.

I walked down to the jam, the one we'd labored in hip boots to haul our canoe through back in June. On this day, I trod carefully on the logs until I could step onto the boat's deck. I looked it over more carefully than I had in June. The deck had serious cracks. The hull was orange, except where it was charred. It looked like someone had tried to burn it. The bottom and part of the sides were blackened. I picked up my cell phone and punched in Pat's number. She didn't answer. I didn't leave a message, knowing my number would show up on her phone. I also knew she was on assignment and pressed for time. But I had to tell her.

Thirty feet from the sailboat, up the slope, is the gravel road. Hiking up there, I can see that it would be easy to haul a fourteen-foot boat back here on a trailer and push it down to the river. At the road's end, I could see a chain-link fence and gate. I walked up to it. Then I walked to the river again. The fence protects the top of a now out-of-service City of Detroit combined sewage overflow: a ten-foot pipe and two gates that used to spew tons of fecal matter, condoms, toilet paper, tampons, and sanitary napkins into the river when it rains hard enough to overload the sewer system.

I'd also noted occasional sewer manholes in the center of the gravel lane. The lane points south toward a Detroit Water and Sewerage Department retention facility at the north end of Eliza Howell Park.

In the spring of 2006, I went back to look for the sailboat again. It was still there, although it had been washed off the top of the logjam and was submerged just downstream.

A few weeks later, I took Pat back for a look. The entire logjam was gone. The whole thing had washed a few hundred yards farther downstream and was lodged at a crook in the river near Kenneth Patterson's bridge.

No sign of the sailboat.

2:38 PM

We are still on the logjam with the sailboat. We pull our canoe higher and higher into the jam. I read the sailboat's registration number into my recorder and then we slide the canoe right over its fiberglass hull. Another car, and the river curves. We are half a mile from Six Mile Road. Water marks on the trees are four feet from the water's surface. The river level is dwindling following last night's rain. We pass another junk car, with the driver and passenger doors wide open in the river and then another car sitting in the woods. We also pass a ten-foot diameter concrete sewer opening with two square metal gates. A nasty sewer stench emanates from it.

3:25 PM

Thunder.

3:34 PM

Logjam number 8. It is followed by number 9 for the day, an easy one.

"That's a car door," Pat says.

Resting parallel with the river is yet another junk car.

3:52 PM

We see another junk car. It makes number eleven. A car in the woods brings the tally to twelve. Sewer stench wafts over us from another two large combined sewer overflow outlets.

4:01 PM

Another junk car, and another.

4:03 PM

Pat shoots pictures of a wooden pallet in the river. We put on our waders as we glide up to a major logjam.

4:48 PM

We hear the muffled sounds of cars. We need a bridge! This next one should be Six Mile.

The last jam took us almost an hour to work our way through. At one point, we had the canoe suspended a good four feet (Pat says less) off the water, hanging from a multitude of logs.

Thank God for the hip boots, but man, are they hurting my feet! I was not aware that the chafing of rubber against flesh had opened sores on my ankles. And somehow I had banged my left shin against a log, or the canoe, and I now have a big cut there.

We should maybe be doing more about injuries, but at home every night, I take a long, hot shower and scrub myself and my wounds with soap. Each night, despite my fatigue, I throw my day's clothes into the washing machine along with our two boat lines stuffed into a pillow case. I start the day in clean clothes and with freshly laundered bow and stern lines. The fact is that there are so many things to think about, I am still greatly excited about what we are doing, yet as the week goes on I grow more and more tired. These cuts get scant attention from me.

That logjam ate a lot of time. We need to get as far as Grand Lawn Cemetery today. There are no good take-out places before the cemetery. I have permission from Steve Doles, cemetery manager, to put in or take out a canoe. The cemetery has a concrete bridge linking the main section to sections on the east side of the Rouge. Near the bridge, there's a lawn where we could drag a canoe to the truck after wrenching it up a steep, muddy bank. We need to get there.

"Don't forget to paddle on the right," Pat reminds me.

4:53 PM

A huge logjam glowers over a junk car with a nearby ten-inch drain gurgling water into the river. Junk car number sixteen sits rusting among the trees.

We've gotten very good at reconnoitering logjams. We slowly nose up to a log and test for low points. We need walkable logs. We remind each other to put on our life jackets. If the first spot looks bad, we back downstream, pivot the canoe, and check another entry point. Once we agree on a starting spot, we go to work.

Ahead, a white house overlooks the river on the east bank. We have our waders and life jackets on. I forget to turn off my recorder. Later, I listen to muffled bumps and groans—complaints from the canoe—as we drag it over logs and brush. We have come through forty-three logjams. Could it be that we would have only nine jams to go between here and Civic Center Drive?

5:26 PM

Waders on again, and we're out of the canoe. Each of us is lifting from opposite sides, pulling the canoe over a log. Is that a bridge we see? Boy, are we ready for a bridge. This could be Six Mile. More jams. We perform lots of calisthenics as we both hop onto trees, scoot over logs, and haul the canoe along the jam, through the mess of flotsam, and back into the stream.

"Intelligence. Brute force," Pat says.

"Looks like we have a bridge ahead of us," I reply. "Salvation."

6:37 PM

A tremendous logjam is stretching ahead of us. We estimate that it's 150 feet long, immediately followed by a second jam. Normally, when I state a distance into my digital recorder, Pat challenges me. She accuses me of exaggerating. "Did you measure it?" she asks again and again. But she agrees on this one. We haul the canoe up a bank, which I guess is fifteen feet above the river. There is no way through or over this one. We unload the canoe and drag it 150 feet after hauling it up the embankment.

We get a call from Nancy Yipe. She is waiting for us at Grand Lawn Cemetery, which closes at dusk. Will we make it? If the cemetery locks its gate, we'll be in trouble. We'll be stuck in the graveyard all night, or we'll have to keep paddling. If it gets dark on us while we're on the river, we'll be in deeper trouble. We are not prepared to camp. Nor are we prepared to leave the

canoe on the river or in the woods. As we talk it over, the canoe grounds itself on a log.

Nancy calls again. She has talked to the cemetery people. They have shown her a pull-out spot at the very southern tip of the graveyard, just north of Six Mile. Put the paddle to the metal, we tell each other. We forget Oakland County. Not today.

7:25 PM

We hear the rumble of thunder again. Before us, on our right, are six huge combined sewer overflow gates. I'd heard of these monsters located just south of Six Mile. These six gates stand between the river and a huge stormwater retention basin. They sometimes dump hundreds of thousands of gallons of raw sewage and rainwater into the Rouge during storms. Mountains of crap, toilet paper, sanitary napkins, condoms, and whatever else people flush down toilets goes straight into the river.

I position the canoe in front of the gates. Pat is taking out a camera. *WHIRRRRR.* We hear the sound of an electric motor. *CLANK.* What machine is that? A pump? A motor opening the gates? We picture the effluent spewing out of those gates. We dig our paddles into the water and push the canoe away as fast as we can.

"That's scary," Pat says. The noise quits. Nothing happens. Pat wants a picture of those gates, so we drift back down, and I position the canoe opposite the gates. Pat snaps a photo. The sewage smell here is awful.

A long, low rumble tumbles out of the sky. More thunder. It is making us nervous. We were lucky once already.

7:32 PM

As we paddle under the Six Mile bridge, we hear Nancy Yipe hollering at us. We can't see her, but she hears us yell back. We are still some distance from her. It begins to sprinkle.

8:05 PM

We arrive at the south end of Grand Lawn Cemetery, just a bit north of Six Mile. Nancy has found this place just in time. It is not a great place to pull out, but it will have to do. The Grand Lawn Cemetery people have left, but they fixed it so we could lock the main gate on our way out. The truck is several hundred yards from the river. I step out of the canoe. Walking in these boots is painful. We haul the canoe up a steep bank. I grab the bow line and drag the canoe through the trees. Man, but walking is a pain! Eventually, we break out of the woods and onto a mown lawn. Ahead, we see grave markers at the crest of a hill. And the Heavner truck.

It is raining now. Again, we are lucky. We have not been rained on while we were on the river. It has been a long, hard day. We were at it twelve hours today, Thursday. And that doesn't count the time we spent schlepping cargo and canoe to and from our launch and take-out spots. We are both very, very tired. We're hot and filthy. Our pants, shirts, hats, arms, hands, and faces

are covered with river muck. Tonight we will forego the Dairy Queen.

Tired as we are, we are remarkably hyped up. We've made it to Six Mile and a bit more. Today we have covered 3.8 miles. It's 2 miles as the crow flies to Eight Mile Road and the Oakland County line. We can do that tomorrow, maybe, but we will need an early start. We agree to meet at the Travelers Building in Southfield at 7:00 AM on Friday. It will be our last shot at reaching Oakland County.

TAKE-OUT AT GRAND LAWN CEMETERY
12 HOURS PADDLED, 3.8 MILES
16 LOGJAMS

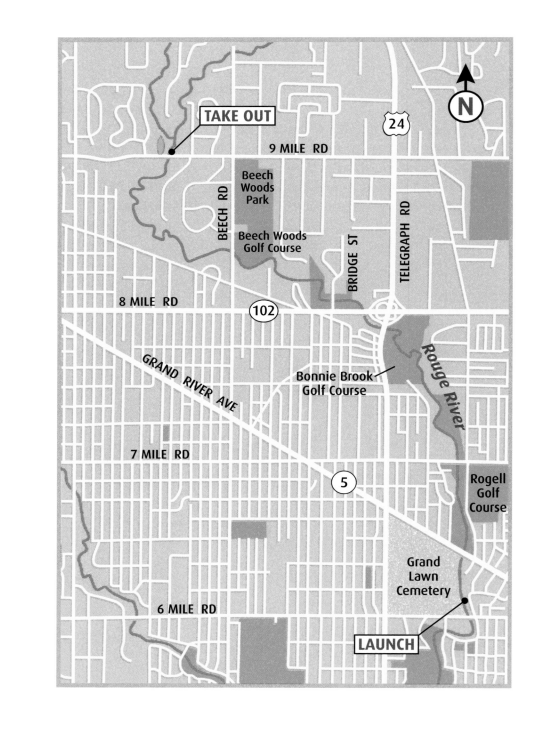

DAY FIVE JAM TODAY

5:00 AM

My alarm just went off, but I was already awake. I am excited—this is the last day of our canoe trek, our last chance to cross into Oakland County. I awoke during the night with pain in my left ankle. My back also tells me that it has been working this week. I am very tired.

"I'm tired," Pat says, as we meet at the Travelers Building. Both Nancy Yipe, who is hauling our canoe, and I were delayed by a wreck on I-696.

Suddenly, I can't recall where I stashed my rubber gloves. Those hard rubber gardener's gloves are almost as essential as the hip boots for our success on this trip. They not only keep our hands dry but they provide strong protection against abrasive trees, logs, and the canoe gunwales and thwarts that we're constantly grabbing and tugging on. The gloves make it easier to han-

dle the lines too. I am sure I packed them, but I can't for the life of me remember where.

"Forget it," I say. I can wear my sailing gloves.

"You need those rubber gloves," Pat says. She mentions a store nearby. I waste precious time going on an errand to buy a pair of rubber gloves. Later, on the water, I find the original pair right where I'd carefully stashed them in a waterproof bag the night before.

Four days of paddling, pushing, towing, pulling, lifting, climbing on trees, and clambering up muddy banks, to say nothing of recordkeeping and picture-taking, have left us very tired. And there is Pat's sore hand and my sore feet. It is a good thing this is the last day. We are both grateful this trip will soon be over.

But we are determined to get as far as we can. We have a job to finish. This is Friday, our last chance. Oakland County is calling us. At Grand Lawn Cemetery, we use the fine restrooms and haul the canoe back to the point just north of Six Mile where we had pulled out last night.

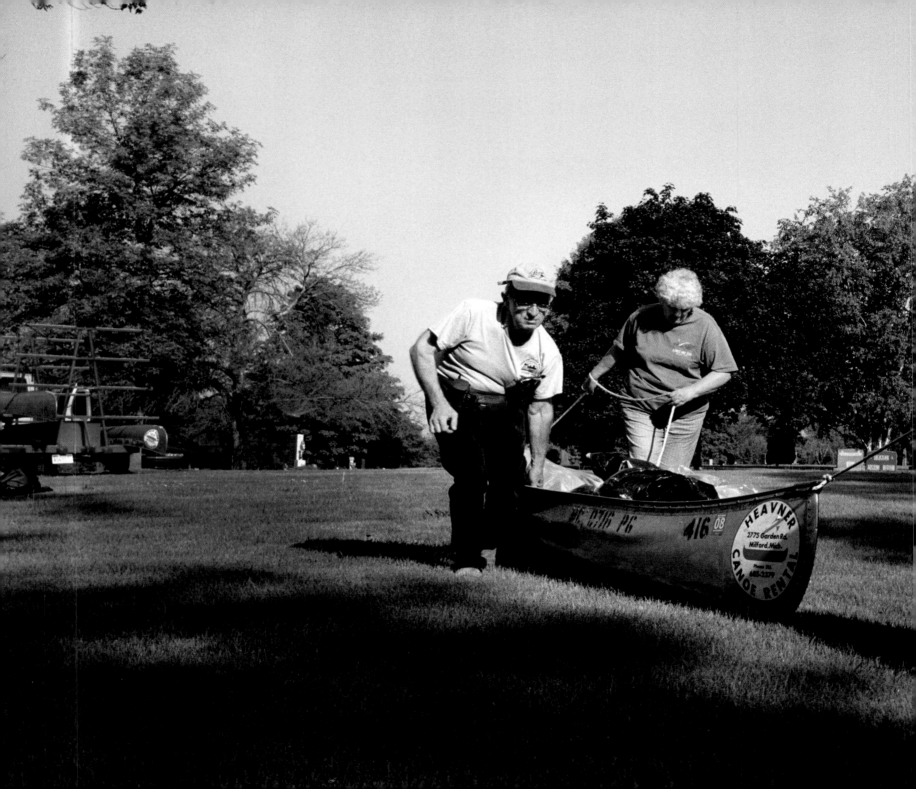

With only one boat ramp on the entire Rouge River, canoeists have to make do with launching their vessels in places that were not intended for that use. At the end of day four, we were forced to find a take-out place that was not part of our plan. With rain starting to fall, night coming on, and many logjams behind us, we were forced to pull out at a remote spot in Detroit's Grand Lawn Cemetery. We then dragged the canoe several hundred yards over a vacant area of the cemetery, where we loaded it onto the Heavner trailer. Here, the next day, with help from Al Heavner and Nancy Yipe, we haul the canoe back through the unused portion of the cemetery and launch it where we had pulled out the night before.

8:52 AM

We're on the water at Grand Lawn Cemetery. Pat pulls out her pruning shears and snips at brush that blocks our way through a logjam. Slowly, methodically, she trims a hole. She stops for a moment, reaches into her waterproof gear bag, pulls out a can of bug spray, and fogs the area around the brush. Then she clips some more.

9:04 AM

We've come upon a complex logjam. I am holding onto a tree, giving us some stability. Pat sits on the bow, kicking floating logs out of our path. She slides back onto her seat as the logs drift out of our way. Immediately, we repeat our act. Pat is pruning. The canoe is parked sideways against a downed tree. Soon, the canoe is pinched between logs. Pat clears a path through the foliage. We zigzag the boat among several logs and then work it through the flotsam of dead trees, bottles, beer cans, and stumps.

9:24 AM

We have just cleared the jam, number 3 already for the day. Pat's right hand is hurting again. She asks me to paddle on the right. Holding her right hand open atop the shaft of the paddle and paddling on the left is less painful than doing the opposite on the other side.

9:42 AM

Clear sky. It's predicted that the thermometer will reach 91 today. It is humid again. Pat complains of fogging

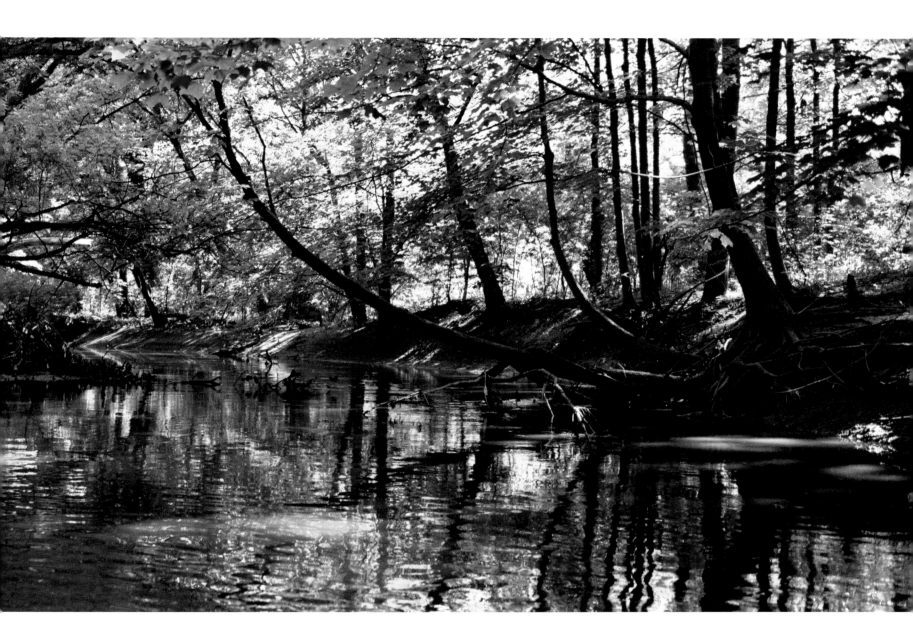

Tree limbs have snagged on a car wheel and axle in the Rogell Golf Course in Detroit.

camera lenses. We are dripping sweat.

We hear traffic noises. Telegraph is to our left and Grand River Avenue is due north. The Grand Lawn Cemetery bridge is dead ahead. I recognize it, having visited the graveyard a couple weeks ago scouting for johns and launch sites. Barn swallows swoop around us as we paddle under the bridge. This spot is like so many on the Rouge: absolutely picturesque. Trees arch over the stream. Vines hang down. All are reflected in the water, deep brown though it is.

The river turns southeast.

10:05 AM

We paddle under the Grand River Avenue bridge. Intermittently, Pat mentions her hand. The pain is more bothersome today. It has awakened her during the night and hurts even when she washes her hair at night. A doctor will tell her later that its cause is the bruise on the inside of her wrist.

On our right, a big lawn stretches away from the river. A man drives a lawn tractor across the yard. Above are nice houses. There is a small bridge just north of Grand River. A small truck drives across the bridge. A mourning dove coos. This is the Rogell Golf Course, and I have walked through part of it, while scouting a few weeks earlier. According to my USGS topo map, it is the Redford Municipal Golf Course, but the map is wrong.

10:32 AM

We paddle hard. Off to our right, a golfer holds his fire as we cross in front of him.

10:40 AM

We have our boots and life jackets on for a big, big jam.

11:04 AM

It took twenty-four minutes to get over that jam. That was number 4 for the day. Our trip total is up to fifty-two. Mark Phillips counted fifty-two jams last year. If our bookkeeping is correct, that should have been the last logjam between us and Civic Center Drive.

We don't believe it.

11:10 AM

We cross under the Seven Mile bridge. On each side, there is a ten-foot-wide sewer outlet. The rank stench of sewage fills the air.

Just north of the bridge are the ruins of an old dam. Concrete still spans much of the river, forcing the current to flow through a narrow gorge at high speed. We make a head-on rush, paddling hard toward the opening, but the current is too strong. Good thing, because we see there is another problem. Sticking out of the concrete at odd angles, some above and some under the water, are pieces of half-inch steel reinforcing rod. They would be great for poking holes in canoes. How lucky that we didn't come upon this from upstream, propelled quickly by the current and out of control on a run through this chute. We decide to stop trying to force our way upstream through this maze of canoe punchers.

To the right we see water flowing between the dam and the bank. It is like a narrow concrete gate. We put the canoe into this opening. Blocking our passage is a ten-speed Huffy bicycle jammed between logs. Pat picks up the bike, twists it, turns it, and breaks it free from the trees that were holding it in place. She pushes it aside and we pass through.

11:43 AM

Big logjam. This is number 53. So much for our numbers game. We have a long way to go and what looks like a steady diet of jams. Pat prunes, hops up on a tree, and I push the canoe. We are clear.

12:15 PM

We pass a pedestrian walkway over the river and two stinking twelve-foot-diameter sewer outlets.

12:17 PM

We see houses on our left and near the bank, lawn chairs, a picnic table, hammock, and a fishing pole.

12:30 PM

A big, big jam lies ahead. So, we push the canoe up against the bank and pull out our standard midday fare of peanut butter and jelly sandwiches, lots of water, and chocolate. We know this next jam is a bad one. A mass of timber towers over us, and there is no weak spot. We need to scout. Stepping out, we slide in the muck. Even in hip boots, there is almost zero traction. We tie our bow line to a tree on the bank and pull ourselves hand over hand up the line. The bank is something like twelve to fifteen feet high. We tromp past trees and through foliage, finding a point fifty feet upstream where we judge we can slide the canoe almost vertically back down to the water, past the logjam. Walking back, Pat points to a broad expanse of three-leafed plants.

"Is that poison ivy?" she asks.

Luckily, our rubber hip boots protect our feet and legs. We haul our gear through the dense poison ivy

patch. Then we haul the canoe, dragging the two lines, through the poison ivy. Our worry now is that the lines have picked up oils from the poison ivy.

1:38 PM

We nose the canoe back into the water. We drag our lines behind us, cleaning them in the muddy Rouge. It is stifling hot and steamy. To our right, we hear a power lawn mower.

"You know, Pat, this is a navigable waterway. We're proving it's navigable. I wonder if we could argue that the federal government or the state of Michigan should clear out these logjams because they're impediments to travel on the Rouge? Really, I wonder if anybody could be held responsible for cleaning up this mess. They've spent hundreds of millions on cleaning up the Rouge. Why couldn't they put a few tens of thousands into clearing out the logjams?"

Back to reality. From the river, I am looking for the Super Kmart on Telegraph Road south of Eight Mile. I scouted the place a few weeks earlier. The store has excellent restrooms, and there is a passable launch site behind its parking lot. But now I can't be sure which building is the Kmart.

1:43 PM

Two more pedestrian bridges pass by overhead. They are in poor condition. We are traveling through the closed Bonniebrook Golf Course. Here we arrive at a true fork in the stream. My map shows the Evans Ditch flowing in from the northeast, on our right. The Rouge bends sharply west just south of Eight Mile. We hear cars. Our seventh logjam for the day is a mean one.

3:02 PM

We pass under Telegraph Road, having just spent the last half hour working through jam number 8.

3:08 PM

We are into another big logjam, and we see a huge turtle.

3:24 PM

Our ninth logjam was really complicated. It is number 57 for the total trip. Again, so much for the magic number of 52. We knew there was nothing precise in that figure, and there's nothing permanent about any logjam. Still, we had hoped that there might be a limit to these tests of our endurance and ingenuity. At 53, I could comfort myself that maybe we'd miscounted. At 54, I wasn't so sure. By 57, we knew these barriers were never going to end. It didn't change anything. As soon as we trekked over our first logjam on day one, we knew the reality was commitment. There was no going back, no heading downstream, once we'd gone over those first jams. Turn around and fight our way back over a logjam we'd already conquered? Never! So, at logjam number 57, we got out and pulled the canoe over two jumbled sets of logs.

3:25 PM

We see Eight Mile!

3:28 PM

We cross under Eight Mile. On the right bank, a gray and white cat welcomes us to Oakland County.

3:36 PM

And here to welcome us also is logjam number 58.

3:45 PM

What bridge is this? It is not on my map, and it looks fairly new. We beach the canoe, so I can hop out. Correction—I slouch out of the canoe, walking very carefully on my tender feet. I have to keep the hip boots on, even though they really hurt my feet. No way can I make it up this steep, mucky bank in my sailboat sandals. Slowly, painfully, I limp up the slope to a street sign. Eight Mile and Bridge Street. Yes, we truly are in Southfield, Oakland County!

I know that recently Oakland County has been given kudos for the fine job it supposedly has done cleaning water that passes down the Rouge to Eight Mile and Detroit. But I stand up here looking back down at the river also knowing that the water is tested at this point, off Bridge Street, just north of Eight Mile. According to Colleen Hughes, an engineer who monitors the test results on water sampled for *E. coli* (the bacteria in fecal matter), in the summer of 2004, the water flowing past this point was unfit for human contact 79 percent of

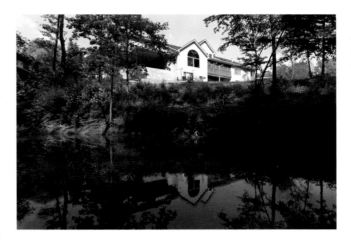

A large, newer house sits atop a slight rise overlooking the Rouge River in Southfield.

the time.

We paddle under Bridge Street.

3:55 PM

Logjam.

4:34 PM

We pass orange brick apartment buildings.

4:38 PM

We glide over concrete and wooden posts under the water, maybe there from an old dam. We don't see these obstructions in time and snag on them. Nearby debris is making a rapids. We miss getting up the chute on our first try, back off, circle around, and head back into the current. This time, we make it. This is the third ruined dam we have crossed.

4:53 PM

Chunks of concrete lying across the river make a rapids. We get out. I pull the canoe by the bow line. Pat pushes the stern. Doing this here is hard. The water is very fast and deep. The trick is to make sure we don't step into water over our heads yet somehow get this canoe through. We stay close to shore and make it.

4:58 PM

We pass houses on our right. A man walking across his yard spots us and approaches the bank. He is Jim Bertram, seventy-six years old, who has lived in his house forty-five years. He tells us that he helped the Friends of the Rouge remove a big logjam just downstream last Saturday.

"A big willow had swung crosswise—you would have had to portage around that one," Jim tells us. Pat and I laugh. We don't do much portaging.

Jim and his neighbor have pumps that draw water out of the river. It's a cheap way for them to sprinkle their lawns. The water may be polluted, but for them it delivers great fertilizer at the same time. Their big complaint against the City of Southfield is that the city wants them to abandon their septic systems and connect to the municipal sewer system. The conversion would cost homeowners ten thousand dollars apiece, Bertram reckons. I refrained from lecturing him on a subject I've heard government environmentalists expound on—that one source of sewage contamination of the Rouge may be these private septic systems. There

are thousands of them in Oakland County. But there is an almost comic irony in the government complaint, it suddenly occurs to me: Jim Bertram's septic system may be leaking human waste into the Rouge. Then again, maybe it's not. We know for sure that the municipal system, despite the outlay of more than a billion dollars, is still dumping sewage into the Rouge. So let's get this straight—the city wants Jim Bertram and his neighbors to convert from their private disposal systems, which only may be leaking, to the city system which surely is a contaminator? Mind-boggling.

Enough chit-chat anyway. Pat wants to get going.

"We're trying to get to Civic Center Drive," she says.

"Let's put the paddle to the metal," I quip.

Jim Bertram tells us that Beech Woods Golf Course is just ahead. I know a little about Beech Woods. A couple weeks earlier, the manager, Doug Moore, put me on a golf cart and drove me down to holes three and four. He showed me a very nice restroom with a flush toilet and sink. He also showed me huge vines of poison ivy climbing up a giant cottonwood tree—and four nasty logjams as well.

"You'll want to portage your canoe around those jams," I remember Doug advising. He showed me where to haul a canoe out at hole three, drag it across the green past hole four and put it back in the water upstream from the last jam.

"I'm going to ask the city to come down here and clear that out on Rouge Cleanup day," he said.

Cleanup day was on Saturday, June 4, just before our trip started, when volunteers like Jim Bertram destroyed a logjam that was flooding their yards along this stretch. I was more than a little curious about whether the City of Southfield had removed those four god-awful jams I'd seen that day at the golf course.

5:30 PM

We glide around a bend and see hole number three at the Beech Woods Golf Course and the nice restroom the manager had showed me when I scouted the place. I was thinking about one thing at this point: getting around or through the four jams I'd seen. We push the canoe over to the bank, and Pat holds the canoe against the shore. I step out and climb up the bank. My ankles and feet ache at every step. A pain on my left shin grows sharper as I walk. I cross the green at hole four. A foursome in neat white clothing chats on the green. I limp by in brown rubber hip boots. My red T-shirt is soaked with sweat. Brown river muck is splattered all over my boots, shirt, and arms. The golfers don't acknowledge me. They say nothing. Nor do I. My feet hurt. My back is tired. I don't feel like talking. I look down at the river for the first logjam. Nothing. Number 2, no problem—we can duck under it. The third looks easy too. I am amazed how my judgment has changed. Most of these jams are low-order messes. But the fourth and last one? Whew! This has to be the mother of all logjams.

The river loops wide to the southwest around the golf course and makes a sharp turn east at hole four. The stream has gouged a new path around a very extensive snarl of logs and whole trees on the east bank. Upstream of the jam is the usual stretch of froth interspersed with trash, floating limbs, and whole trees.

I limp back across the green at hole three and report my findings to Pat.

"We could take out here," I conclude—and be done. Doug Moore had even offered to send a golf course truck to haul our canoe. "We've made it to Oakland County."

Pat thinks. "We've still got time. Let's not stop so soon," she says. "Maybe we can make it to Civic Center Drive."

That's just what I want to hear. Despite our fatigue, I don't want to quit either. We are still excited. We have made it into Oakland County, and maybe, just maybe, we can get to Civic Center Drive near our office. Pat really wants someone to take a picture of us in the canoe. I call Nancy Yipe, who is hanging out at the Travelers Building. She offers to buy a disposable camera and take our picture when she picks us up. Civic Center Drive, here we come.

Logjams 1, 2, and 3 at Beech Woods are a piece of cake. Below an apartment building on the river bank opposite hole four, we pass six shopping carts. We maneuver past what looks like a sunken Dumpster and a milk crate. The last logjam, however, is a marvel. We work the canoe high up onto overhanging logs. Ultimately, the brush and logs are too dense. We wind up having to portage. We are finally back in the water at 6:22 PM.

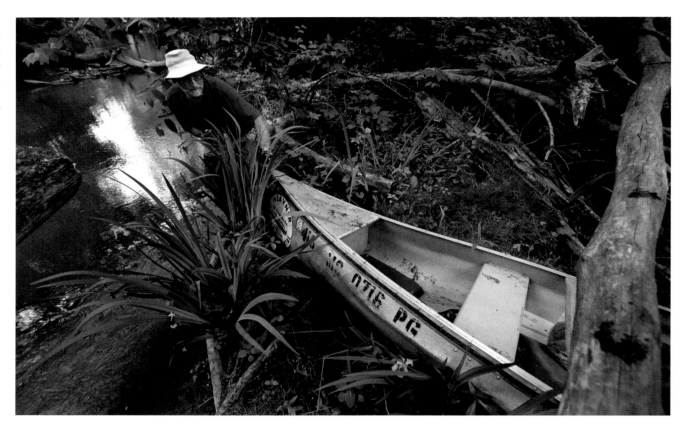

The author pulls the canoe along the river bank, under a fallen tree, and back toward the water during a portage at Beech Woods Golf Course in Southfield. Portaging was necessary to get around really large logjams.

During the weeks after our trip, I learned more about the giant logjam at the fourth green at Beech Woods Golf Course. It sometimes causes flooding across the green, but it is one logjam the City of Southfield's logjam czar, Steve Marshall, insists must not be removed. It is located at a sharp bend in the river, and it prevents the current from undercutting a steep bank. An apartment building perches at the top of this bank.

6:27 PM

We paddle under the Beech Road bridge. Civic Center Drive is not seeming quite as doable any longer. The map shows that it's roughly two-thirds of a mile straight up Beech Road to Nine Mile. But the Rouge has another idea. It meanders off northwest and then arches back to the east.

6:38 PM

We are through the eighteenth logjam for the day, bringing the total to sixty-six. The water here is shallow. At times we just push off the bottom with our paddles—it is too shallow to actually paddle.

SOMETIME BEFORE 7:00 PM

Thunder and rain, once again. During the morning on this final day, my recorder jammed, so I borrowed a steno pad and pen from Pat. From time to time I have been pulling out the pad from its protective Ziploc bag and jotting brief notes. It hasn't been easy, and now the notebook is getting wet. I also need my hands to paddle.

6:43 PM

Logjam 19 is behind us, and so is logjam number 20 for the day. We're developing a fixation on our total for the trip. We've clambered over and through a remarkable sixty-eight logjams.

7:08 PM

Logjam 21 goes by. The water is still too shallow to paddle, and the canoe is grounding often. We hop out, wading now and towing the canoe along with ropes.

7:17 PM

Logjam 22. I bump my head on a low branch, and it knocks off my hat. Into the brown Rouge it drops, turning slowly as it begins to sink. Of course, here we

A multiflora rose blooms along the banks of the Rouge River in Southfield.

are paddling in deeper water again and no longer wading. We swing the canoe around, aiming for the hat. It drifts away. I try to catch it with my paddle. I miss. We swing farther downstream and watch the hat go under. We can see it two inches below the surface, and then three inches. At four inches, it simply vanishes into the opaque brownness of the river.

The river is shallow again. We jump out and pull the canoe.

We cross two more logjams, bringing the total to seventy-two.

Seventy-two logjams. We are amazed. And I know there are more between Nine Mile and Civic Center Drive. Three weeks ago, behind the parking lot of Meriwether's Restaurant at Telegraph Road and Ten Mile, where a fat raccoon was eyeing the Dumpster, I saw what I took for a massive logjam on what I believed

to be an arm of the Rouge. It might not look so tough today though. We have become good at this work. We are wondering, though, whether the water might continue to be this shallow north of Nine Mile. That will force us to walk the river, pulling the canoe.

7:00–8:00 PM

I talk to Nancy Yipe on my cell phone. She is at Nine Mile, she says, but it turns out that she is east of Telegraph, having tracked the Evans Ditch through a golf course. Wrong branch of the Rouge.

SOMETIME AFTER 9:00 PM

We come to a bridge. Is it Nine Mile? We see no sign of Nancy. We ground the canoe. It is getting dark. Pat stays with the boat, and I limp up the bank, push through trees, and hike up the slope to the road. My feet are hurting, as usual, as I slowly walk a couple hundred yards west. I can see there is a street sign. Slowly, hurting at each step, I walk closer to it. Nine Mile. I call Nancy.

"Come west down Nine Mile," I tell her. Slowly, I walk back to the canoe. Pat and I unload our gear.

Too bad about Civic Center Drive, also known to us as Ten-and-a-Half Mile Road. That means our goal is just a mile and a half as the crow flies from where we're stopping for good, having used up our allotted five days. Of course, "as the crow flies" deflates the actual mileage of the river, which slants and winds in ways that would confound a crow. And it doesn't account for the frequent blockages, the logjams that have entertained us for the last four days. Civic Center Drive leads east toward Southfield's municipal complex, within sight of our *Free Press* Oakland County newsroom in the highrise Travelers Building.

Privately, we both vow that someday we will team up and return to Nine Mile Road to finish our trip.

For now, we are tired. This is the end of the line. With great effort we carry our gear up the embankment and lay it out of sight behind the guardrail. We drag the canoe up, and just as we are hoisting it over the guardrail, the Heavner truck pulls up. It is a welcome sight, but we are also feeling sad that we didn't get a picture of us together in the canoe.

We've been at work fourteen hours today. Wow. In five days, we've traveled 27.3 miles on the Rouge, a 60.5-hour workweek. Seventy-two logjams crossed, three of them portaged. We pushed, pulled, tugged, and lifted our canoe through sixty-nine of these incredible messes. We portaged the dam at Fair Lane and pulled the canoe through three ruined dams.

We are hot and sweaty. Exhausted. Pat's hand hurts. My back aches. I can really feel the wounds on my ankles, and now I am noticing scratches on my hands and arms that I hadn't seen before. Around the cuts, the flesh is red and swollen.

9:45 PM

"Serious hat hair," Pat says, as we enter the Travelers Building. We are headed to the restrooms for a quick

cleanup. Passing the large plate glass window at the deli, we see that hat hair is the least of our problems. The two people mirrored in the window are covered with Rouge River slime. Their arms are bruised, scratched, and scraped. Their faces are filthy.

A celebratory dinner is in order, Pat says. We recall the little girl we scared at the Dairy Queen and decide we should go someplace where we can't be seen. A drive-in would be best. Sitting in my car, we order burgers and root beer floats at the Berkley A&W. The hamburgers taste better than steak.

We review the tallies of our trip as we eat. Two barges. Seventy-two logjams. Four dams. Sixteen junk cars. A green heron, two common mergansers, two dogs, a sunken houseboat, a wrecked sailboat, and lots of turtles, great blue herons, and mallards. We didn't lose a camera. And we never tipped over the canoe. We did lose one thing—my hat.

But we did it!

Up the Rouge!

TAKE-OUT AT NINE MILE AND BEECH
11 HOURS PADDLED, 5.9 MILES
24 LOGJAMS

TRIP SUMMARY
TOTAL MILES TRAVELED: 27.3
TOTAL HOURS PADDLED: 52.5
TOTAL TRIP HOURS (PADDLING PLUS LAUNCH AND TAKE-OUT): 60.5
TOTAL LOGJAMS: 72 (3 PORTAGED, 69 CROSSED)
TOTAL OBSTACLES: 76 (1 DAM, 3 RUINED DAMS)

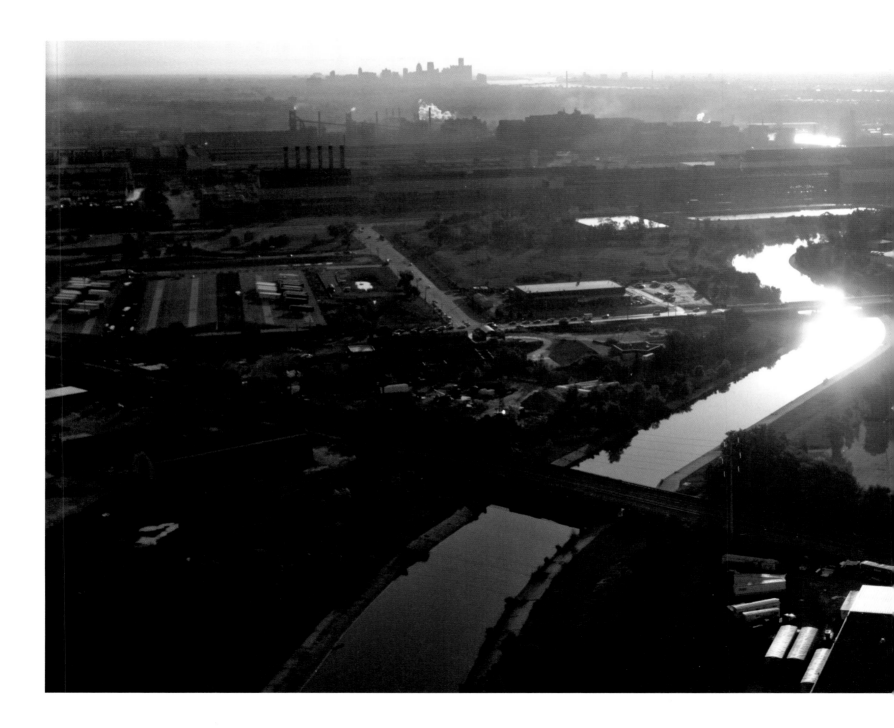

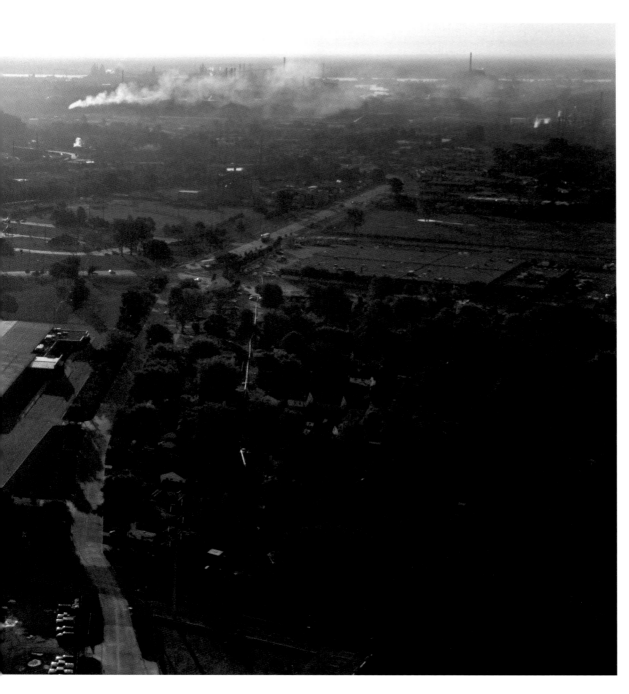

Sunlight reflects off a curve in the channelized part of the Rouge River in this aerial view looking southeast toward the Detroit River in August 2005. The skyline of Detroit is visible in the distance at the upper left.

EPILOGUE

Pat Beck and I canoed more than twenty-seven miles up the Rouge River, and it was hard work. We think it would be great if other people could canoe up the Rouge and see this amazing woods-cloaked river but with less trouble and physical risk than we experienced. For this to be possible, we would need to remove the logjams and encourage people to canoe the river.

Pat and I were with Steve Marshall, the Southfield "logjam killer," one day when he directed a group of some twenty Oakland County jail inmates in removing logjams along the Rouge in Southfield. I asked him how much he thought it would cost to remove all the jams on the Rouge Main Branch. Marshall said he could take out every one on the Rouge for $1 million to $2 million—one million if he used convicts for the labor and two million if he hired the work done.

Think about it: even $2 million is a drop in the bucket compared to the $1.3 billion governments have spent so far to improve the Rouge. I've asked for an accounting of the expenditures and been told it doesn't exist. Do it yourself. While I know that much of the money has been spent on "hardware"—wastewater treatment improvements, sewerage equipment upgrades, replacement sewer interceptors that accept suburbanites' ever-increasing loads of waste—I know there are "soft" sums that could have been used to remove logjams. What about the $100,000 Oakland County spent in 2005 on a poster, a logo for the Rouge, and a party celebrating (somewhat prematurely) its reclamation? What about the $100,000-plus that the Rouge Gateway Partnership consortium of communities, colleges, and businesses paid for architects to draw up a master plan of business and tourist uses for the river? Worthy, perhaps, but is that part of an integrated vision for the Rouge and for the Great Lakes? A hundred thousand here, a hundred thousand there, and pretty soon you've got enough to kill all the logjams from Dearborn Heights to Rochester Hills.

I know, I know—logos and posters and parties raise public awareness of the Rouge. But it seems to me that when advertising agencies are being hired to help save the Rouge, it's a sign that too much money is being spent on remedies that are marginally effective at best. In 2003, the federal Government Accountability Office

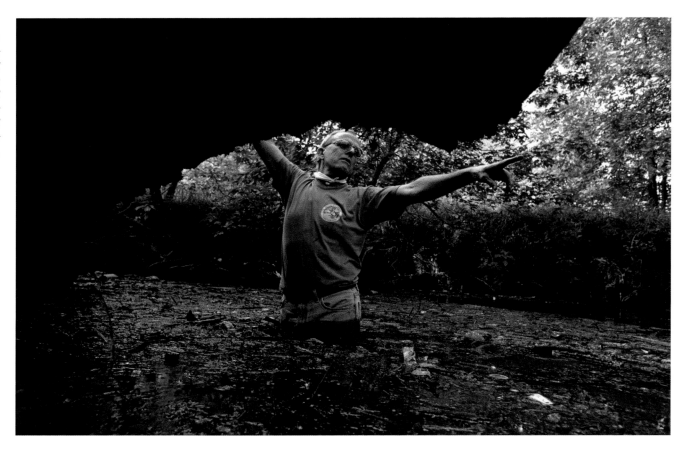

lambasted the U.S. Environmental Protection Agency for failing to provide an "overarching" plan for improving water quality in the Great Lakes. Everybody wants to help, it seems, but the state, counties, and various private organizations pull in different directions, not always putting resources where they'll do the most good.

Figure this one out: on the nearby Huron River, the state Department of Natural Resources clears logjams, and there's a thriving canoe livery business as a result. Thousands of people get up close to the Huron every summer. On the Rouge north of Eight Mile Road, Southfield has an aggressive logjam removal program. But elsewhere in the Rouge watershed, Friends of the Rouge has made logjam-killing a taboo subject. Because of the multitude of blockages in the river, nobody

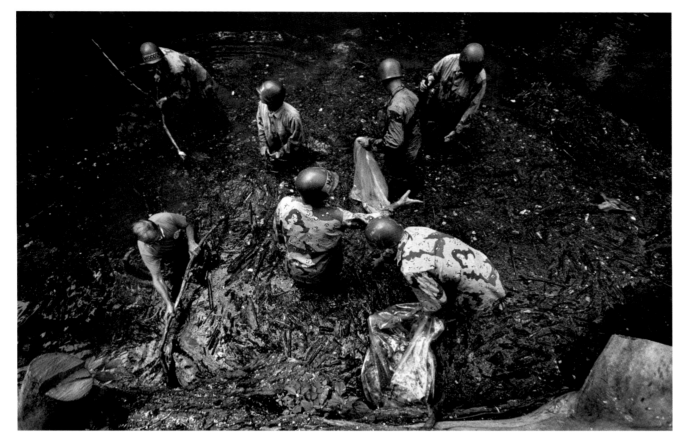

Steve Marshall (at lower left, in green T-shirt) directs a crew picking up the small debris from a logjam they've just cleared. He's using a stick to gather floating detritus. The trainees are with the Oakland County Sheriff's Department Regimented Inmate Disciplinary Program. All of the logjam was removed except for one large tree trunk that Marshall would remove later with heavy equipment.

canoes the Rouge. Well, except for Pat and me, almost nobody.

Every summer for more than thirty years Marshall has led groups of volunteers or convicts in a never-ending attempt to clear logjams from Southfield's nine miles of Rouge River. Marshall insists that logjams induce flooding on a river already prone to flashy ups and downs; logjams catch debris, oils, junk, and other contaminants rather than allowing them to flow downstream. And they impede canoeists, not that many people try canoeing, even in Southfield. Pat and I learned that even in an area where logjam removal is taken seriously, there are lots of jams. Marshall likened the process to keeping your kitchen floor clean. It's a cycle that goes on forever.

Marshall's view is unorthodox. The official line

with Friends of the Rouge is that the group doesn't "clear" logjams. Rather, its volunteers merely "open" them, providing an aperture for the free flow of water while leaving "woody debris" to provide cover for fish and other wildlife. But that's an argument that runs in circles. Where are the fish? Except in a few places where the state has stocked them—Newburgh Lake and Johnson Creek, for example—there's not much of a fishery to talk about. The river is too flood-prone for fish to breed. Oh sure, you see fish in the industrial Rouge, but they are mostly carp. I know some people like to eat carp, but they're the dominant fish in that area, state fisheries biologist Jeff Braunscheidel told me. If there were a viable fish habitat, where pike, walleye, bass, and bluegill might spawn, the state might stock fish there.

Meanwhile, spawning is blocked in many spots of the Rouge by those power dams installed by Henry Ford on former grist mill sites in the early twentieth century. Dams in Northville, Plymouth, Livonia, and Westland block fish on the Middle Rouge, and the dam at Ford's Fair Lane mansion stops fish from moving up the Main Branch. A fish passage has been proposed at Fair Lane. It would cost $1 million. As for logjam removal, there is no money for that.

No money can be found for a proposal to modify the concrete culvert that lines the Rouge for four miles between Michigan Avenue and the Ford Rouge auto factory either. The idea is to remove some of the concrete and create wetlands alongside the river so that fish can feed and spawn.

None of these projects—all of which would help restore recreation to the Rouge—is considered to be enough of a priority for government agencies to pay for them.

Braunscheidel told me salmon have been seen on the Lower Rouge as far upstream as Wayne, where they are blocked by an old water-pump dam. But salmon don't spawn in the Rouge, and he stressed that there is no significant fish population in the river except for Newburgh Lake on the Middle Rouge in Livonia, where it was created by dredging pollutants from the soil at a cost of $12 million, so there would be fewer fish health advisories, and in Johnson Creek, a tributary of the Middle Rouge, where the state stocks brown trout every year. But the fish are threatened in Johnson Creek, where sediment from construction is burying their feeding areas.

Take away the dams so fish can swim upstream and spawn and you still have to contend with that "flashiness" that scared us more than once when we got caught in the rain. Those water-stained tree trunks are measures of the rapidity with which the Rouge can flood, thanks to runoff from acres and acres of hard surfaces and from many construction sites, where soil-laden rainwater sheets straight to the river.

So the argument that logjams provide habitat for fish seems weak to me. What fish? And what habitat, when it can be washed away in an instant?

Even birds have a problem living and breeding along the Rouge. Julie Craves of the Rouge River Bird

Observatory at the University of Michigan–Dearborn explained to me that breeding is hopeless for species of birds that nest low along the river. Flash floods wipe out their broods.

How do you stop the flooding? A Detroit printer named Edward Hines had an answer in the early twentieth century. He convinced Wayne County's government to buy most of the flood plain along the Middle Rouge between Northville and Dearborn Heights. Nobody can build there because it's a public parkway. But that solution wasn't applied to the rest of the Rouge, where buildings have often been built precariously close to the banks. Restrictive land-use laws, had they been imposed in the early and mid-twentieth century, could have prevented much of the development that now sends huge volumes of water to the Rouge. The lesson hasn't been learned to this day because the building goes on and the sediment keeps flowing into feeder creeks and on into the major branches. Witness the troubled trout in Johnson Creek.

I've pondered the logjam issue plenty. It's not politically correct to speak of removing logjams. Yet I wonder at environmentally acute people who condemn the practice. The same people who say logjams provide shelter for wildlife and should be spared will rail at the dams that block fish passage, warm the water, and send silt—when released by a dam breach—downstream to cover feeding grounds. But aren't logjams a form of dam? Wouldn't the same objections apply to them?

The key thing that we know about logjams is that

A ball floats along with other debris trapped by a logjam in Southfield. The logjam was removed by Steve Marshall and his crew of jail inmates. Trash like this ball is bagged and sent to a landfill.

they are dangerous. They can suck hapless canoeists into their snarls and drown them.

The choice is pretty clear. If we want the river to be navigable, we must completely clear out most if not all of the logjams. If no one clears the logjams, they will stay until they are washed away. The natural state of the river will be to have as many logjams as nature creates. Did the first explorers whose upstream trip we were trying to emulate encounter massive logjams too? And what about the Ojibwas and Potawatomis who camped alongside the Rouge? I know from reading Helen Hornbeck Tanner's book *Atlas of Great Lakes Indian History* (University of Oklahoma Press, 1987) that there were Potowatomi and Ojibwa Indian camps on the main branch of the Rouge in the late 1700s. The book doesn't say what they did about logjams, which seem inevitable on any stream, small or large. We know too that nineteenth-century pioneers like Israel and

After dragging the canoe from a nearby road, through the woods, and to the river's edge, the author launches it early on a June morning. Along the twenty-seven-mile length of the Rouge River covered by the five-day canoe trip, from the source at the Detroit River up into Southfield, there is only one public boat launch, at Melvindale, and we didn't use it. Our launch spots most often were near bridges, which allowed the canoe van to park near the bank.

Laura Bell traversed the forests of what would later be Detroit and its suburbs by paddling or poling boats up the Rouge. I suspect the river was much easier on humans and wildlife in those days. Steve Marshall told me when he first started leading cleanups in the 1970s, the Rouge in Southfield was a mere creek. The flooding that would sometimes overtop the bridge at Nine Mile Road is a phenomenon that came in recent years, he said. If the river wasn't as flashy then, and if high, fast-moving water didn't erode the banks and undercut the trees as much, there may have been fewer blockages.

If we want people to be really committed to the Rouge River, we have to open it to them. Let people find out for themselves that a little wilderness lies in the city, waiting to be discovered and explored. Okay, so it's polluted. If we wait until its waters comply with state water quality standards, we might never send canoes up the Rouge. But if people start doing recreation on the river now, they may be moved to push governments to do more to stop polluting it and clean it up. And they may be moved to think twice about waste management, what kinds of chemicals they put on their lawns, etc. Even better, they might understand how connected we are through that river—Northville to Detroit, Rochester to Melvindale, Farmington Hills to Dearborn.

Why shouldn't we be able to canoe the Rouge as easily as people paddle the nearby Huron River? An open Rouge River could become a winding line of unification, something that would draw suburbs and the Big City together. For example, but for the canoe

106

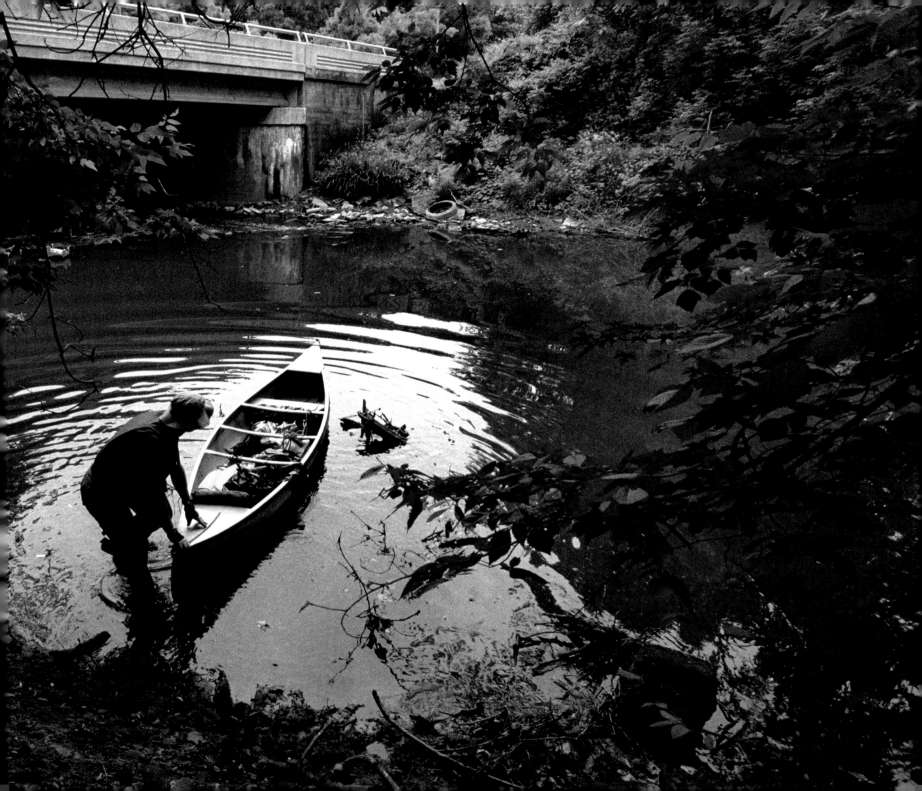

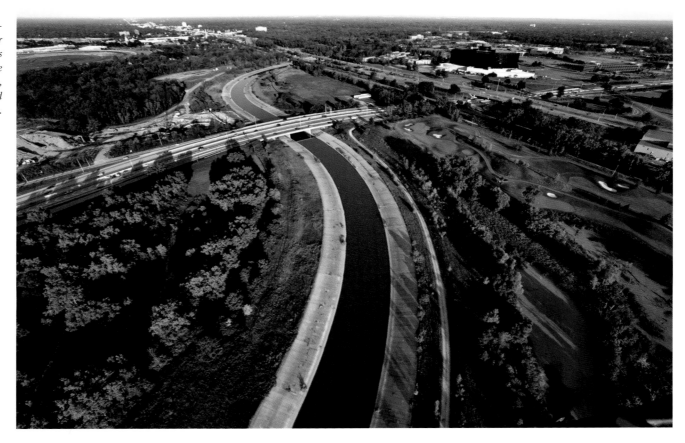

An aerial view looking west-northwest up the Rouge River in Dearborn. The river flows under the Michigan Avenue bridge, near the top of the photo, and then under the Southfield Freeway bridge.

trip, I would never have met Kenneth Patterson, the Rouge River bridge builder. I remember marveling as we paddled under that suspension bridge he built north of Fenkell. Who would build such a thing, and why? Why, a guy who likes to hold parties on the banks of the Rouge. Ken Patterson's bridge is a metaphor for what needs to be done with this river.

The river itself is a bridge.

One more thing: It doesn't take $1.3 billion and offices full of highly paid consultants and engineers to clear out logjams. It takes will. If we will the clearing of the river—bring people to it instead of pushing them away—the will to find new, better ways of cleaning the Rouge will follow. One day a year, the Friends of the

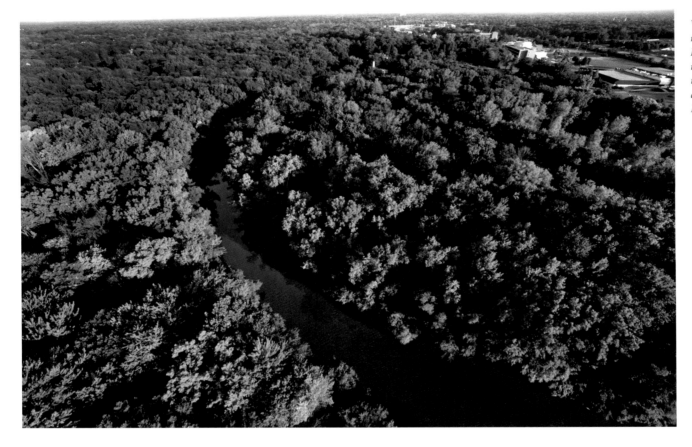

Woods surround much of the natural course of the Rouge River's Main Branch, making it a truly hidden river. Here, the Rouge flows through a heavily treed section of Dearborn.

Rouge brings people to clean up the river. Rip out the logjams, and people can canoe or kayak the river any time they wish.

Another thing: sewage continues to be a problem in the Rouge River. A big part of this problem boils down to the very human need we have to relieve ourselves. Since the onset of indoor plumbing and the de- mise of the outhouse, water has been the chief means of propelling human waste out of our homes and out of sight. What if there were another way of disposing of our waste? What if there were a way of reducing the amount of human waste we send to Detroit's sewer system? What if we required every second, third, or fourth toilet in a home to be an incinerator, or maybe a com-

posting toilet? Burn the poop or turn it into sanitized fertilizer. We give tax credits to people who buy hybrid cars. Why not give a tax credit or even a direct subsidy to people who install alternative toilets?

There must be cheaper, more effective ways of cleaning the Rouge. We need to imagine them.

On Saturday, the day after we finished canoeing the Rouge, my wife Karen had a sixtieth birthday party for me at our sailing club in Oakland County. Pontiac Yacht Club is on Cass Lake, which is part of the Clinton River, a different watershed but one that also has suffered from sewage pollution. In fact, sometimes the health department bans swimming from the club beach when *E. coli* counts are too high.

Pat came to the party with a brace on her right wrist. She said her doctor told her not to lift anything with that hand. The doctor noted the swelling around her wrist and said a bruise there was connected to the pain in her hand. By Saturday, she couldn't close it without great pain. If we'd continued the trip on Saturday, it would have been very hard.

I was still limping from painful feet, though the antibiotic Karen prescribed was beginning to subdue the infections on my hands and feet.

My editors, Kathy O'Gorman and Laura Varon Brown, were there. We felt quite triumphant, like explorers returned from a difficult expedition. Funny thing was that we hadn't needed passports and we hadn't left metro Detroit.

Some of my friends at the party were a bit confused about just what we had been trying to do. That was the next challenge: explaining to readers and colleagues in story form what this trip was about.

Telling the story turned out to be not so easy. The log-form narrative we'd counted on for storytelling wound up being jettisoned in favor of a conventional mode of delivery. The series ran on October 19 and October 20, 2005. Our stories and photos later won the 2006 Harry E. Schlenz Medal for Achievement in Public Education from the Water Environment Federation. Because of the stories, we've been invited to talk and show photos to local environmental groups, schools, and community and church organizations.

Through giving these talks, we've learned that many, many people share our love for this abused river as well as our hope that it can, despite discouraging signs to the contrary, be improved both for humans and for wildlife.

Although we imagined we were doing irreparable damage to the canoe, the fifteen-foot aluminum vessel named *The Huron* by Al Heavner was returned to the livery's fleet and continues to be Nancy Yipe's favorite. In the spring of 2008, when Pat and I decided to continue the trip by launching a canoe at Nine Mile Road and trying to make it to Civic Center Drive, our original goal, I called Al Heavner and asked if we could rent that canoe. I learned that the canoe had in no way been damaged and had recently received a fancy paint job.

What about other people trying to do what we

did? There'd been concern about inspiring copycats who might hurt themselves. Frankly, I'd always hoped our stories might prompt others to try canoeing the Rouge to learn firsthand about both the abuse and the beauty of the river. I haven't heard of anybody doing it, though.

As I was making final corrections to the manuscript for *Up the Rouge!* I received an e-mail from a Friends of the Rouge staffer asking if I'd once again help them find junk cars in or around the Rouge. In our *Free Press* series, I wrote about those junk cars, and Pat's photos dramatically showed how people have trashed the river. Friends of the Rouge was spurred to take action, and the group found a construction contractor willing to donate heavy equipment and workers to haul cars out during the June 2006 cleanup. Pat and I had done a story about that too, and the following year I took Friends of the Rouge staffers on a tour of junk car sites. In June 2007, I watched front-end loaders lift more cars out of the river. It was satisfying to know that our work had put a public spotlight on this one aspect of the river's mistreatment, and it was coming to some good.

One day in spring 2008, three years after our Rouge canoe trip, I got a call from a man who said Al Heavner wanted him to contact me about his proposed ten-day canoe voyage up the Huron River. I pretended to be shocked. Upstream? I said. What are you, nuts?

No, he said, it makes sense because the explorers would have come from the big water and paddled up the river.

Hmmm. Where had I heard that?

But you know, the Huron is easy. I have a better idea.

Up the Rouge!

APPENDIX A ROUGE RIVER DATA

ROUGE RIVER WATERSHED FACTS

Area	466 square miles
Human population	1.5 million
Counties	3
Municipalities	48
Lakes and ponds	400
River length in miles	126

(Source: Southeastern Michigan Council of Governments)

AVERAGE OF MEAN ANNUAL JUNE STREAMFLOW PER DECADE IN CUBIC FEET PER SECOND

1931–40	54
1941–50	113
1951–60	80
1961–70	124
1971–80	116
1981–90	139
1991–2000	187

The June streamflow increased by a factor of 3.5 between 1931–40 and 1991–2000.

(Source: U.S. Geological Survey)

COMPARISON OF SOME ROUGE RIVER AND HURON RIVER CHARACTERISTICS AND AMENITIES

	Rouge River	Huron River*
Canoe liveries	0	4
Public boat access sites	1	23
Public restrooms	1	23
Fishing	Brown trout in Johnson Creek tributary; bass and pike in Newburgh Lake on Middle Rouge branch; some salmon and channel catfish but mostly carp in industrial Lower Rouge	Pike, rock bass, smallmouth bass, largemouth bass, sunfish, rainbow and brook trout, yellow perch, bluegill, pumpkinseed, black crappie, walleye
Bottom	Mud, concrete	Gravel, cobble, boulder

* The Huron River watershed lies adjacent to the Rouge River watershed. They are neighbors, yet the Huron is far better known. The Huron once was polluted, though not to the extent the Rouge was and still is contaminated. Many public parks along the Huron with several ponds and lakes offer canoeing, sailing, and fishing, and picnicking beside the Huron is common.

(Source: Rouge River Watershed Map by Rouge River National Wet Weather Demonstration Project, Huron-Clinton Metroparks Authority)

APPENDIX B THINGS TO TAKE

Early in our planning for the Rouge River trip, Pat and I talked about the things we'd need to bring with us. Our list is included here with comments about items that we decided after five days of travel were either useful or unnecessary.

TRANSPORTATION

Canoe. An eighteen-foot aluminum Michi-Craft canoe gave us greater carrying capacity and stability on the Detroit River and wider parts of Lower Rouge on day one. On the following four days, we used a fifteen-foot aluminum Michi-Craft canoe for its lightness and maneuverability in winding, narrow areas north of Michigan Avenue and while combating logjams. It turned out that the eighteen-footer with its stability was a good thing when we were buffeted by gusts reaching thirty miles per hour. The fifteen-footer turned out to be great for negotiating shallow water too.

Paddles. Standard canoe-livery plastic paddles, long ones. We brought three, so we'd have a spare in case we lost one.

Cars. Pat and I each drove our own cars as we commuted daily to the canoe expedition. We parked our cars in relatively secure areas, either at the Henry Ford Estate in Dearborn or the Travelers Building in Southfield. From those locations, we'd either launch the canoe or board the Heavner van for a ride to the river. In the evening we'd go back to our cars and head to our separate homes, in Plymouth Township for me and in Southfield for Pat.

TOOLS

Depth poles. Six-foot broomsticks marked at one-foot intervals were very useful as depth gauges and for poking at things or poling the canoe.

Binoculars. Binoculars were useful at first but became a pain in the neck when the going got rough.

Roger Tory Peterson's *A Field Guide to the Birds of Eastern and Central North America.* We left the bird book in the car, as there was no time for research on the trip. We did find it useful later for identifying birds we saw.

Bow saw. We left it in the car.

Machete. We also left it in the car.

Pruning shears. We hadn't thought of these before the trip, but we brought them along later; they turned out to be very useful for clearing foliage.

Gloves. Open-fingered sailing or biking gloves helped to protect against blisters while paddling. Rubber gardening gloves became essential. We wore them whenever we had to put our hands in the Rouge River water. We had along leather gloves for protection when we were moving rough logs, etc.

Safety pin. For fastening hat to shirt; Pat likes to point out that she did this and I did not. My hat was the only gear we lost, but hey—who wants to have a hat pinned to him?

Garden kneeling pad. This slim foam pad turned out to be most useful as a perch for the camera pouches. It kept them from

bouncing on the canoe bottom and out of the water that got inside the boat. Pat also put her camera gear inside a black plastic garbage bag to minimize the black yucky water from reaching the gear.

Ropes. We chose a couple forty-foot three-eighths-inch nylon lines. They were good for hauling the canoe over logjams. We had one on the bow and one on the stern and found them absolutely essential.

Stretch cords. I thought bungee cords would be useful for tying things down in case we should capsize. We left them in my car.

NAVIGATIONAL AIDS

Maps. You can't buy specialized sectional maps of the Rouge River. So we took U.S. Geological Survey maps of the region from the Detroit River to Rochester Hills, which also included the Rouge River as a feature, and had them arranged in eight 8½-by-11-inch sections, produced with National Geographic Society software. I had each map laminated in plastic, so they would withstand exposure to water and muck. That turns out to have been a good idea. The maps were always wet and often caked with dark Rouge River mud.

Map holder. A clear plastic envelope large enough to hold all eight laminated maps was really useful. I bought the holder at a sporting goods store. It was tied to the thwart in front of me in the canoe and was essential for keeping the maps safe and handy.

Compass. I brought along a small compass that I bought at a sporting goods store. We used it only once where the river was winding and we had become confused about our whereabouts. Next time, I'll take a global positioning system device for more accurately noting where we saw certain things and just always knowing our precise location.

Waterproof watch. I wore my regular Timex digital watch, which is supposedly good to a depth of one hundred meters. Pat bought a new waterproof analog Timex. Telling time was key to figuring out how far we might get in a day.

Cell phone. A cell phone was indispensable for emergencies and letting the canoe livery people know where to find us at day's end.

CLOTHING

Convertible pants. These are light khaki pants with zippered leg sections that can be removed to turn the pants into shorts. It's a great idea. However, despite temperatures in the nineties, we never felt hot enough to bother converting to shorts. Besides, the pants gave our legs protection from snagging branches. These pants dried very quickly too.

Shirts. Pat wore a polo shirt for neck protection. I wore a T-shirt. We each ran all our clothing through the washing machine each night for a fresh start the next morning. The first day, we each had along spare clothes in case we got drenched. After day one, Pat dispensed with extra clothes. I kept a change of clothes in a plastic waterproof container and never used them.

Long-sleeved denim shirt. Pat brought along a long-sleeved shirt in case she needed to protect her arms when going through brush. I preferred T-shirts, though, because they were cooler.

Rain gear. I kept a rain parka in the waterproof container with my extra clothes. It rained more than once, but I never used the parka.

Hat. We wore floppy-brimmed hats. They were good to have. As noted, Pat pinned the neck strap of her hat to her shirt. Next time, I'll buy a hat that floats.

Footgear. My hard-toed boat sandals would have been okay with socks; Pat recommends tennis shoes and socks. I prefer not having to tie and untie.

Chest waders. The chest waders turned out to be useless at best and unsafe at worst. After the first day, when they only increased the weight of our cargo, we no longer brought them along.

Hip boots. Essential!

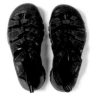

FOOD AND WATER

Bananas. The bananas we brought along turned to mush with all the logjam activity, so we quit bringing them.

Chocolate. Even during hot weather, we recommend a big bar of chocolate containing a high percentage of cocoa. It provides a nice energy boost and is a great thing for a break between logjams.

Cookies. Cookies are also nice for breaks.

Peanut butter and jelly sandwiches. PB&J sandwiches are easy to make, filling, and they give nice energy without generating thirst.

Bottled drinking water. Frozen overnight, our bottled drinking water stayed cool for hours. We consumed four to six twelve-ounce bottles apiece each day.

CONTAINERS

Hard plastic waterproof container. I had originally bought a hard plastic waterproof container for my sailboat to keep my cell phone dry. I bought it at a sporting goods store. It's a small box with a hinged cover big enough to hold both my cell phone and digital recorder. I kept the phone in the box, and when we approached a logjam I'd place the recorder in there as well.

Soft plastic tube-type watertight containers. These soft plastic containers are available at sporting goods stores. They were good for organizing and keeping dry spare clothes, gloves, and anything we weren't using at the moment.

Waterproof roll-top pouches with securing clips. Pat used a roll-top waterproof pouch for each of her cameras and lenses. All the smaller pouches were placed inside a larger waterproof pouch. We used one of these for the binoculars as well.

Coolers. We used coolers to store food, water, and film. Pat used a small soft-sided cooler for her film rolls, which she kept inside their individual plastic film containers in Ziploc freezer bags. The little cooler went inside one of the larger roll-top waterproof containers tied to the canoe.

HEALTH, SAFETY, AND SANITATION ITEMS

Insect repellent. We brought along both lotion and spray types of insect repellent. Pat often fogged foliage before pruning.

Suntan lotion. We did not want to suffer any pain from sunburn, so we used plenty of suntan lotion. On the first day we were in the sun the entire day. Later, we had some shelter under the tree canopy along much of the river.

Life jackets. Life jackets were a must when walking on logjams. We wore them throughout day one on the Detroit River and the Lower Rouge.

First-aid kit. Essential, although we never used ours.

Liquid antibacterial hand cleaner. We found hand cleaner to be useful before eating to clean the filth off our hands. We couldn't wash them clean in the Rouge River!

Wet wipes disposable towelettes. We also used wet wipes to clean our hands before eating.

Paper towels. A roll of paper towels was useful for cleaning up anything and everything, especially around lunchtime.

Toilet paper and a trowel.

Garbage bags. We found garbage bags most useful for storing and protecting our life jackets, except when we had the vests on, which was while going over logjams or when paddling hard, especially on day one. Eventually, we placed the large camera pouch in a garbage bag to limit its exposure to muddy water in the bottom of the canoe.

IDENTIFICATION

Driver's license. We carried along plastic-laminated photocopies of our driver's licenses.

Identification card. Pat and I both brought along laminated photocopies of our *Detroit Free Press* ID cards and kept them in a Ziploc bag in the side pockets of our convertible pants. They proved useful when we were interrogated by four workers at the gypsum company's wharf.

RECORDKEEPING EQUIPMENT

Digital audio recorder. Without this neat little device, there would be no *Up the Rouge!* I kept the digital audio recorder on a lanyard around my neck, easy to grab and turn on when I wanted to comment. I put it in a waterproof box along with my cell phone while we worked our way over logjams. Once the memory was full halfway through the last day, I was forced to make notes by hand on a notepad bummed from Pat that got wet and muddy. Writing is hard to do in a tippy canoe, especially when paddling and logjam duties are almost constant. My hand notes were terse compared to my audio comments. I could turn the recorder on and keep paddling.

Notebooks. Pat always brought one, and it turned out to be essential as a backup.

Sketchpad. I kept a small sketchpad in a zippered pants pocket, but there was no leisure time for drawing. It was useless.

Pens and pencils. We brought pencils as a backup in case the pens failed, but they didn't.

Waterproof permanent marker. A marker was important for Pat's labeling of film rolls with number and day.

Cameras. Pat recorded the canoe trip with three cameras: a Hasselblad XPan panoramic camera (which she said was "very cool" and she'd use again), a Noblex 135U panoramic camera with rotating lens (which she would not recommend for a canoe trip because it needs to be positioned perfectly level to the scene, otherwise the horizon line distorts, so it worked all right in the tree-lined stretches of the Rouge but poorly in the industrial area from the low vantage point of the canoe), and a Canon EOS-1N 35mm film camera with three different lenses: a Canon Zoom Lens EF 16–35mm 1:2.8 L (good for shooting many things), a Canon Macro Lens EF 100mm 1:2.8 (good for close-ups of small things like flowers, golf balls in the mud, and damselflies), and a Canon Zoom Lens EF 100–400mm 1:4.5–5.6 L IS (good for photographing birds, turtles, and other things impossible to get close to and nice because the internal image stabilizer helped lessen the effects of the canoe's movements). Pat said she used the Canon film camera most but wished she could have had her digital camera along most of all. It records the time each photo is taken, and it's possible to change ISO settings at any moment, which would been handy going from bright sunlight one minute into deep shade and then back into bright sunlight. But, it would have been a lot of camera to lose had we capsized.

Film. Pat's film of choice was Fujicolor Press 800 and Fujicolor Press 400 professional film 135-36 (which means 35mm size in 36-exposure rolls). Each day she brought along ten to twelve rolls, using the slower, finer grained ISO 400 film early in the trip out in the wide open and on bright-sky days, and using the faster but grainier ISO 800 film in the tree-covered stretches and on the more overcast days. Pat shot a total of twenty rolls of film during the five days of canoeing.

Lens tissues. Lens tissues were essential for keeping the camera lenses clean, although Pat says she rarely used them on the actual trip. She made sure each day before she left the house that the lenses were clean and used the tissues only if water splashed on the glass or they fogged up, which didn't happen often. She added that she was hesitant to touch the lens glass unless really necessary because it was so hot and humid every day, and because her hands were often wet and almost always dirty.

WHO WE ARE

PATRICIA BECK has been a *Detroit Free Press* staff photographer since 1977. She has been honored with numerous awards, including the Robert F. Kennedy Award for outstanding Coverage of the Problems of the Disadvantaged, Grand Prize, for her work on a 1990 series titled "Workers At Risk." Beck lives in Southfield, Michigan, with her two cats, Benny and Rose, and the menagerie of birds and small animals that frequent her backyard.

JOEL THURTELL had been a journalist for thirty years when he retired as a reporter from the *Detroit Free Press* in 2007.

He has been a farm worker, printer's helper, taxicab co-owner, foundryman, woodshop worker, congressional aide, rural mail carrier, Manhattan deli counterman, and a Peace Corps volunteer. He currently lives in Plymouth Township, Michigan, with his wife, Karen Fonde, and their dog, Patty.

In 2006, Beck and Thurtell won the Harry E. Schlenz Medal for Achievement in Public Education of the Water Environment Federation for their work on the *Detroit Free Press*'s Rouge River series of October 19–20, 2005.

Library of Congress Cataloging-in-Publication Data

Thurtell, Joel, 1945–

Up the Rouge! : paddling Detroit's hidden river /
text by Joel Thurtell ; photographs by Patricia Beck.

p. cm.

"A Painted Turtle book."

ISBN 978-0-8143-3425-6 (paper : alk. paper)

1. Natural history—Michigan—Rouge, River (River)

2. Water—Pollution—Michigan—Rouge, River (River)

3. Rouge, River (Mich. : River) I. Title.

QH104.5.R68T48 2009

508.774'3—dc22

2008025007

Designed by Chang Jae Lee

Typeset by Maya Rhodes

Composed in Minion and Interstate